HOW TO PAINT
MADE EASY

Water

Acrylics

Oil

Digital

Materials

Inspiration

Step-by-Steps

INTRODUCTORY TEXT
DIGITAL PAINTING:
DAVID COUSENS
TRADITIONAL PAINTING:
SHARMAINE KWAN

FOREWORD
TOM HOVEY

FLAME TREE
PUBLISHING

CONTENTS

No matter what kind of artist you are, you will need a few basic materials. This chapter looks at what you might need, whether you are planning to paint with watercolour, acrylic, oil, ink, gouache, pastels, pencils or charcoal, or are choosing to experiment with digital painting.

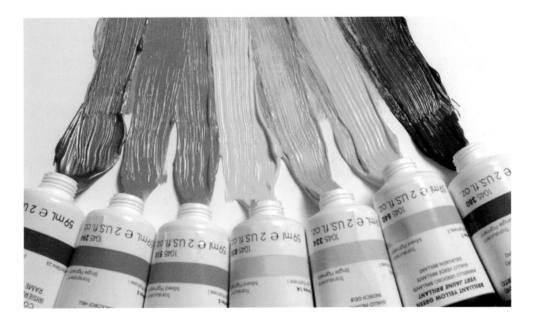

CONSTRUCT YOUR PAINTING 26

Before starting your painting, you need to think about how the picture will be constructed. In this chapter, you'll learn to think about composition, perspective, proportion and depth, and see numerous working examples to help get you going.

START PAINTING 40

Whether you are creating a painting using traditional materials or digitally, colour and texture are two elements that it is important to get right. This chapter will introduce you to the basics of colour theory, and show you how adding textures, layers and washes to your painting can enhance the finished piece.

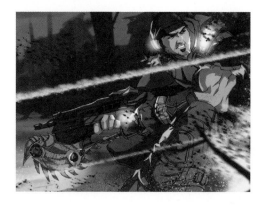

BRINGING YOUR PAINTING TO LIFE 70

Any artwork can be brought to life by the careful use of light and shade, and by creating the impression of movement. This chapter will demonstrate, with the help of numerous examples, both traditional and digital, how this can be done.

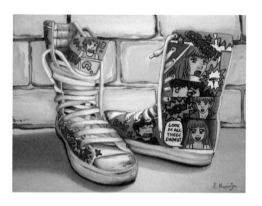

This chapter will give you inspiration for your next still life. Follow the artists, step by step, through their still-life projects, and pick up some top tips along the way.

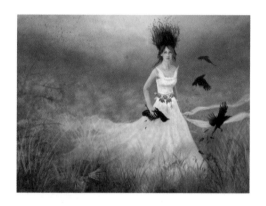

In this chapter, artists demonstrate how they paint faces and figures, both human and animal. Learn how to use colour, textures, light and shade, proportion and digital effects in your artwork to bring your subject to life.

The outside world, both urban and rural, has always been a great source of inspiration for artists. Take a look at the projects in this chapter and see how to capture the essence of the world outside your front door.

ABSTRACT STYLE204

This chapter contains a wealth of abstract projects, created in a variety of media, using a multitude of techniques. Let your imagination be your guide, and create an abstract work of art.

FOREWORD

Like many kids growing up with a passion for drawing, I didn't know where it would lead, but I always knew I wanted to be an artist.

Painting always seemed like the end goal for anyone who had an ambition to be an artist. I pored over the books of the great masters – Dalí, Monet and Picasso – in my parents' house, and imagined one day being a painter like them. I had no idea how to make that dream into a reality, but luckily it never, for whatever reason, seemed like an unattainable goal.

I was fortunate to have an uncle who was an artist; he saw my interest and would give me a different painting set every Christmas: coloured inks, tubes of watercolours and acrylic paints and canvases. I can still remember the thrill of opening up each jar of ink or piercing the lid of a tube of paint for the first time. Having access to these new and exciting tools enabled me to play, experiment and learn in my own time.

I try to revive this feeling whenever I'm in a creative funk and need to kickstart things. If I have been working in a particular medium for a long time, I know that I can down tools and crack open the acrylics or the watercolours and do something completely different for an hour, an afternoon or a day, depending how burned out I am feeling. These periods of free expression and playtime can open up creative doorways that you could never have come across had you not taken the time to try something new.

I've worked as an illustrator for 10 years, using many different styles and approaches to many different jobs. For the most part, I was an analogue illustrator and used a few digital processes to refine things. But, in the past few years, that pendulum has swung the other way, and analogue is now a small part of my working process with digital work taking up the majority of my time.

After my initial trepidation at losing myself and my soul to the dark side of digital painting, I soon realized that Photoshop is merely a tool, just like a palette of acrylics and a paint brush. Once you've mastered the basics, the possibilities of digital art are infinite. There are now myriad paint media and brush styles available to use digitally, which opens up a world of opportunities to experiment and create artwork.

I am self-taught on all the digital programs I use, just like I am self-taught in every analogue drawing and painting approach I use. I see learning new skills as an important part of my working life and I will continue to develop and add to my skill base.

Whatever kind of artist you are or would like to be, hopefully this book will offer you some guidance and help you to achieve your artistic ambitions.

Tom Hovey
Illustrator, artist and designer
tomhovey.co.uk

INTRODUCTION

Most of us were introduced to painting as children. We used fingers and poster paint on large swaths of paper. Colours were blended and mixed together. Textures appeared as products of our hands, sponges or large, flat brushes. Everything was an expression of freedom, an experiment. This book will bring you back to those joyous days, and help you to rediscover the sheer fun of painting a picture.

WHERE TO START?

Maybe you have always had the desire to paint, but are not sure how to begin. Do you want to paint using traditional materials, or do you want to try your hand at using one of the multitude of digital painting apps on your mobile device or home computer? There are so many options

that it can be completely overwhelming when you are just starting out. *How to Paint* will give you great advice based on the experience of a wide range of artists working in a wide range of styles. It will give you the necessary skills – either to adhere to or challenge – that allowed such artists as Edgar Degas, Henri Matisse and Georgia O'Keeffe to become household names.

Admiring the craft of such famous and influential artists, however, may prevent many prospective painters from taking the leap. This book will help you take the first steps on your creative journey.

TRADITIONAL PAINTING

If you decide to have a go at traditional painting, you will need some appropriate materials. In an art supply store, there are so many choices that it can be a little off-putting at first. What kind of paint do I need? Do I need paper or canvas? Should I use a specific kind of brush? In the first chapter of the book, artist Sharmaine Kwan looks at some of the most common painting media: watercolour, gouache, acrylic, oil, ink, as well as pastels, pencils and charcoal, and provides a helpful roundup of what materials – ground (paper, canvas etc.), brushes, thinners, cleaners and other apparatus – you will need for each medium.

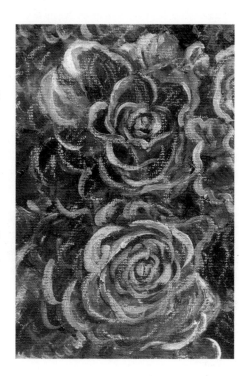

DIGITAL PAINTING

Digital artist David Cousens will provide you with a foundation knowledge of digital painting. The advanced technology of digital painting now affords artists the opportunity to mimic traditional methods to a surprising degree. You will be guided through creating and editing

digital images in popular apps and programs such as Adobe Photoshop, Corel Painter and Smith Micro's Clip Studio. We will also review some of the hardware of digital painting, from tablets to styluses.

PAINTING TECHNIQUES

In addition to assessing what materials you may require, we also discuss how to create a solid, successful composition. The second, third and fourth chapters of the book show you that there is much more to producing a dynamic artwork than simply reproducing your subject accurately on paper, canvas or screen; how you use perspective, colour, light and shade are, in many ways, more important than the medium (or media) you choose to employ.

INSPIRATIONAL ARTWORKS

The final four chapters include step-by-step projects in a variety of genres – still life, portrait, landscape and abstract, each with its own place in art history. Whatever you choose to start with is a matter of taste, but *How to Paint* will encourage you to try them all. By experimenting with the different genres, you will discover which you feel most affinity with and which are the most enjoyable for you to create.

LEARN FROM OTHERS

Throughout the book, we have included examples, step-by-step projects and in-depth tutorials created by a collection of artists and designers. Some are self-taught, others are formally educated, and their talents span a multitude of genres. The projects are of varying lengths and styles, presented by each artist in his or her own way. Some are very detailed and will take you a while to work through; others are shorter; but they are all packed with information and ideas you can use.

One of the best ways to develop your own style is to study how other artists create their work, and then go on to find your own way of doing things: be inspired by the knowledge that many well-known, successful artists, including Jack Vettriano and Beryl Cook, started out painting in their spare time, learning their craft by observing the work of others in galleries and books. Their artwork is now prized by collectors and sells for thousands!

HAVE A GO!

A solid foundation is the key to learning any new skill and painting is no different. This book will give you the confidence to try out different styles of painting, so that it becomes as effortless and enjoyable as those childhood days with poster paint and paper. Be inspired by the myriad ideas presented by our artists, and then let your own imagination run wild.

Acrylic

To work in this medium, you will need:

- 🎨 **Acrylic paints**: An acrylic paint set is ideal, as it will contain a basic variety of colours.
- 🎨 **A water container**
- 🎨 **Brushes**: Synthetic, natural or a combination of both. The type of brush you use depends on the effect you are after and what surface you are painting on.
- 🎨 **A paint palette**
- 🎨 **A palette knife**: Used occasionally.
- 🎨 **Surface to paint on**: Acrylics can be painted on most surfaces, but are usually used on paper, canvas and board.

Quick Tip: Heavy-body acrylics have a thicker consistency like oil paints and are more suitable when painting in impasto. Fluid acrylics are thinner in terms of consistency and should be used to paint details or create an effect similar to watercolour.

Oil

The equipment you will require includes:

- **Brushes**: With stiff hairs.
- **Oil paint**: An oil paint set is ideal, as it will contain a basic variety of colours.
- **Palette knives**
- **Medium containers**
- **A paint palette**: Wooden, glass or disposable paper palettes are all fine.
- **A canvas or primed surface to paint on**
- **Oil mediums**: Refined linseed oil and liquin will speed up or slow down the drying time as well as giving the surface a glossy finish.
- **Brush cleaner**: Thinners, e.g. turpentine or odourless mineral spirits, in a cleaning jar (from good art supply outlets).

Ink

You will need:

- **Ink**: Pigment-based, dye-based or waterproof.
- **A container or palette**
- **Brushes**: You may also want to use a metal nib dip pen or a bamboo dip pen for drawing lines.
- **A water container**

- **Paper/Surface**: Hot-pressed watercolour paper has a smoother surface which is more suitable for drawing lines or fine details, whereas heavyweight paper with a rough surface may create a dry, textured look.

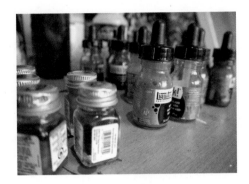

Gouache

Gouache is similar to watercolour except that it has an opaque quality. The standard equipment you would need would include gouache paint, a water container, a paint palette, brushes and paper.

Pastels

Pastels are a useful medium, and the various kinds are suitable for different types of artwork situations:

- **Soft pastels**: These are powdery and are suitable for blending and creating painterly effects.
- **Hard pastels**: These are less fragile and are used more for drawing.
- **Oil pastels**: These have a waxy characteristic and do not smudge easily, allowing strong strokes to be drawn.
- **Pastel pencils**: These give you more control and are used to create detailed drawings and to make preliminary sketches.

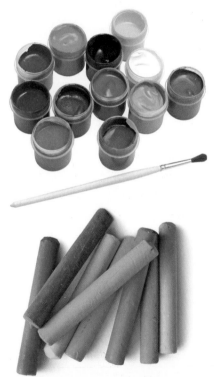

Quick Tip: Try experimenting with other types of paper and surfaces such as Chinese rice paper.

Pencils

There are many different types of pencil, from standard graphite pencils to precise mechanical ones. The number and letter on the pencil refers to the hardness of the lead.

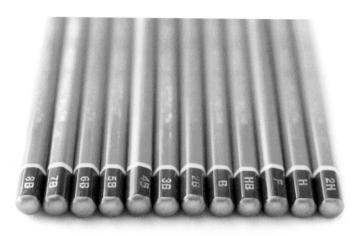

- **H numbers**: The higher the H number, the harder the lead (e.g. a 5H creates a lighter line than a 2H).
- **B numbers**: The higher the B number, the darker the line, as it has a softer lead (e.g. a 4B is darker than a 2B).

Charcoal

Willow and vine charcoals are quite soft and powdery and can be smudged easily. Compressed charcoal sticks and charcoal pencils are slightly harder and are useful for drawing lines and details. You may also want to use fixative to protect your drawing from smudging.

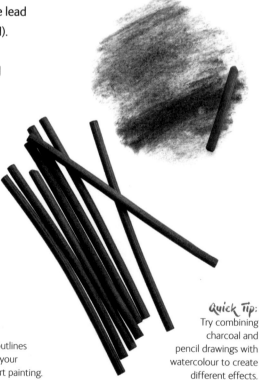

Quick Tip: Harder leads are typically used for drawing outlines and softer leads for darker lines and shading. Try drawing your compositions in pencil on paper or canvas before you start painting.

Quick Tip: Try combining charcoal and pencil drawings with watercolour to create different effects.

GENERAL EQUIPMENT

As well as the medium-specific materials given above, you should also have to hand:

- **Eraser**: Rubber or kneadable.
- **Sharpener or sharpening knife**
- **Metal clips**
- **Paper towels/cloth**
- **Newspaper**

Easels

You may need to use an easel for works on canvas or large paintings on paper that are attached to a drawing board for support. A-frame easels and single-mast easels are usually used and are easy to store. Larger works would require H-frame easels as they have a sturdier base. Tabletop easels can be used for small works and portable aluminium easels are recommended if you are painting outdoors or on location.

Inspirational Artworks

Included throughout the book are dozens of artworks in all the media described here to inspire you to pick up a pencil or brush. What are you waiting for?

MATERIALS & EQUIPMENT FOR DIGITAL PAINTING

In some ways, digital painting is very similar to traditional analogue painting, and in others it is drastically different. Where digital art was once purely for technical drawings, technology has improved rapidly, offering techniques and results that are very similar to the real thing, only without the chance of getting paint on your clothes!

GETTING STARTED

There are a huge number of apps available for digital artists to choose from. Here, we will look at a few of the most popular and readily available. See also page 253 for more top digital painting apps.

Adobe Photoshop

Adobe Photoshop is the industry standard for creating digital art. With it you can paint, draw, animate, render 3D and photo manipulate, and it supports many useful plugins. It is available from Adobe, either on an individual app subscription basis or as part of the Creative Cloud subscription. Photoshop has a steep learning curve for beginners, but once you've got a handle on it, it is a powerful and resourceful tool.

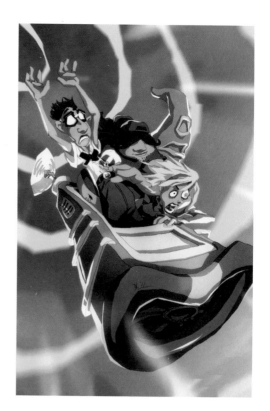

Clip Studio

Smith Micro's Clip Studio has gained in popularity in recent years, thanks to some outstanding drawing tools. It includes tailor-made comic drawing resources, such as comic panel generation, smart rulers and line straightening.

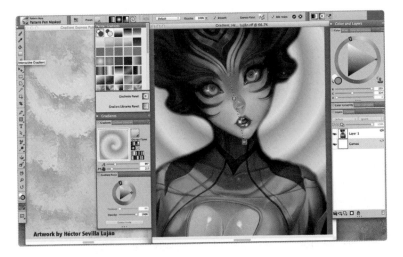

Artwork by Héctor Sevilla Luján

Corel Painter

Corel Painter is another strong contender. While it doesn't offer some of Photoshop's advanced tricks, it has specialized in acting and feeling as close to natural media as possible.

It's worth trying out a number of apps; use the free trials so you can see which suits you best.

TABLET TIME

If you're going to make digital art, you'll need to get a graphics tablet that you plug into your PC or Mac (ordinary touch-screen tablets are not suitable for drawing, even if you can write on their screens). The dark days of people creating artwork with a mouse or track-pad are long gone, and it's madness to try using those tools (not just for efficiency's sake – track-pads are a huge RSI risk, and nobody wants that!).

Different Budgets, Different options

There are some decent brands available, including Apple iPad Pros, Samsung Galaxy Note tablets and phablets with S-Pen styluses and Microsoft Surface Pro tablets, but the market standard is set by Wacom. Even their lowest budget range tablets, the Intuos (as pictured below), offer excellent pressure sensitivity and tilt responsiveness, which is crucial for digital painting.

Some tablets are peripheral devices, like the Intuos, but it is becoming increasingly common with higher-end models like the Wacom Cintiq (pictured opposite, top), which acts as a second monitor, or the MobileStudio Pro, which acts as a tablet PC as well, to use the stylus to draw directly on to the screen for a very natural feeling and intuitive workflow.

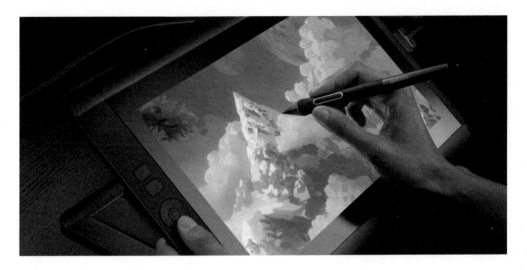

The Stylus

Using a graphics tablet and stylus lets you achieve amazing results and will help speed up your workflow. Digital styluses, like the Apple Pencil pictured below, are lightweight and give you so much more control over your artwork than a mouse or finger; they're pressure sensitive and can respond to the angle you tilt it at. The apps you use respond to this and change your brushmarks accordingly.

Intuitive Control

Graphics tablets have programmable hotkeys built into them which allow you to map your most-used commands to them, saving you time and increasing your workflow. Tablets also come with gesture controls enabled, allowing for greater and more naturalistic control over commands such as zooming and re-sizing.

Digital Examples

Included throughout the book are many examples of fantastic artworks produced either solely digitally, or with digital elements as part of the artistic process. Read on and discover more.

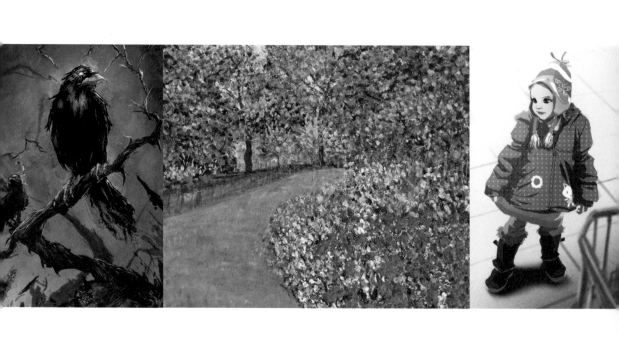

Construct Your Painting

COMPOSITION & PERSPECTIVE

Composition is about the arrangement of elements, the use of space and creating balance or contrast, as well as guiding the viewers' eyes around the areas of interest. It is important to plan your composition before you start as it forms the framework of your painting.

Rule of Thirds

The rule of thirds is a guideline that suggests that if you divide your composition vertically and horizontally into thirds and position focal points along the division lines or areas of intersection, it will become more visually engaging. This watercolour painting, *Seaside*, by Sharmaine Kwan is a good example of this.

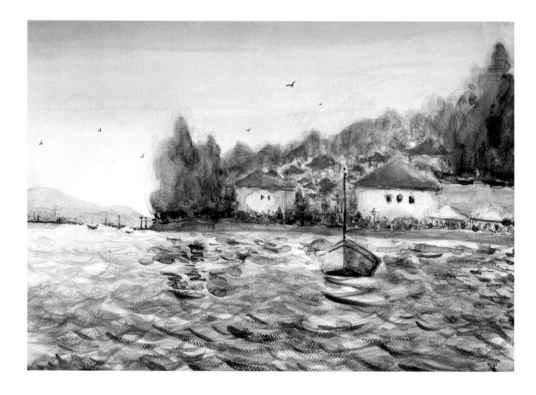

One-Point Perspective

One-point perspective can be used to convey an illusion of distance. An example would be a road that appears to continue indefinitely and disappear into the horizon. One-point perspective uses one vanishing point on the horizon line, as shown in the illustration to the right.

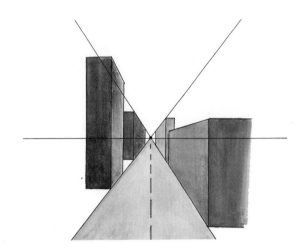

Two-Point Perspective

Two-point perspective has two vanishing points on opposite sides along the horizon line. The object is at an angle and you can see the two sides that recede towards the vanishing points. It is useful in making objects appear 3D, as you can see in the illustration to the right.

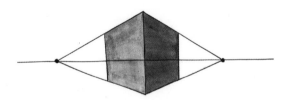

Three-Point Perspective

Three-point perspective has an extra vanishing point either above or below the horizon line to create the illusion of height. It can be used to depict buildings and cityscapes from an aerial view or from ground view.

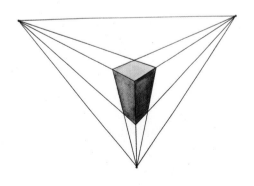

Positioning Your Images

These digitally created images show how important it is to get the composition right; adjusting your subject a few millimetres either way can make the difference between a good painting and a great painting.

PORTAL CHELL
BY DAVID COUSENS
PAINTING APPLICATION: PHOTOSHOP

Where you position your characters within a scene determines how your audience will feel about them. Having a character positioned centrally makes them feel stable and powerful, and is often a great choice for determined heroes like Chell.

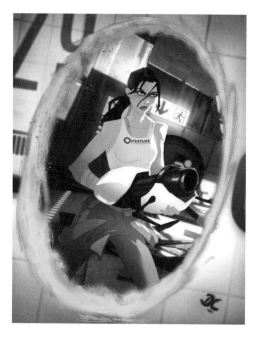

LOVEBIRDS
BY DAVID COUSENS
PAINTING APPLICATION:
COREL PAINTER AND PHOTOSHOP

In chaotic images like this,, I find it helpful to guide the viewer subtly around the painting using elements already in the image. The branches here all point towards the main focal point: the red crow.

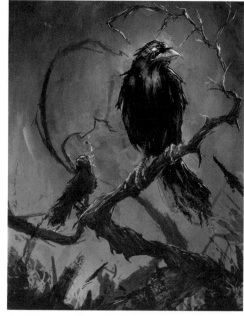

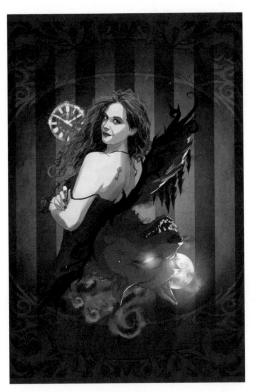

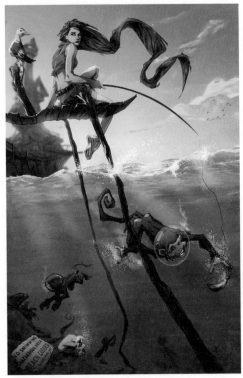

THE GATHERING POSTER
BY DAVID COUSENS
PAINTING APPLICATION: PHOTOSHOP

This promotional poster was designed
to be rotated in the same manner as a
playing card, so I made sure the woman's
head and wolf's face lined up in the
same position, as do the glowing clock
and the moon.

SEA MONKEYS
BY DAVID COUSENS
PAINTING APPLICATION: PHOTOSHOP

Everything in this image leads to the next
part in a clockwise fashion, The girl's hair
and fishing line lead to the monkey, whose
arm leads to the banana which curves
back towards the other elements, continuing
the circle.

LANDSCAPE
BY SEBASTIAN
MEDIUM: GOUACHE

Step 1

I first laid out a rough sketch of the landscape, outlining the fields and trees with a thinned-out cobalt blue. I focused on the direction of the lines so as to draw the eye in to a focal point in the centre of the painting.

Step 2

I began by painting the distant trees and fields at the back. The colours of these were more muted so as to give the painting more depth.

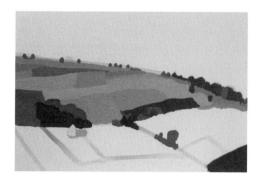

Step 3

As I worked my way forward from the distant fields, the colours became more vibrant. I used a darker viridian green for the trees behind, a lighter viridian for those in front and cobalt blue for the shadows.

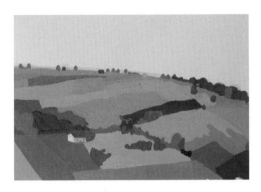

Step 4

I continued filling in the fields with light yellow, blends of greens and red umber. I also added a farmhouse in towards the front.

Step 5

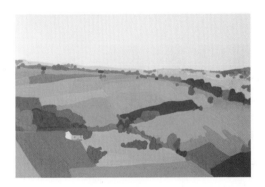

To give the painting more depth, I added in a new line of distant hills in the background, using a pastel green.

Final Painting

For the sky, I used a flat 14 synthetic brush, using a rough cross-hatching technique, with the colour becoming lighter and lighter, from cobalt blue to white. I added in some distant houses and trees as a finishing touch.

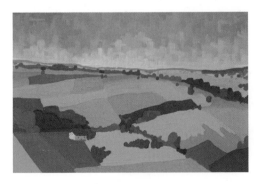

Quick Tip: Tricks of perception are also used in portrait and landscape paintings. An example is how the eyes of Leonardo da Vinci's famous portrait Mona Lisa appears to follow you. This is because paintings are flat surfaces and the eyes which look straight out do not change regardless of the viewing angle. This idea of visual perception is used in many works and is based on how the brain interprets 2D imagery into 3D.

PROPORTION & DEPTH

Proportion is about the relationships between elements: how they relate to each other in terms of size and space, whether it be realistic or exaggerated. Depth helps to draw in your view and adds an illusionistic 3D aspect to your painting.

Getting Your Proportion Right

Before you start painting, you can draw lines, grids or the geometric shape of your subject to help with your proportions. Observe the space between objects and their size in relation to one another.

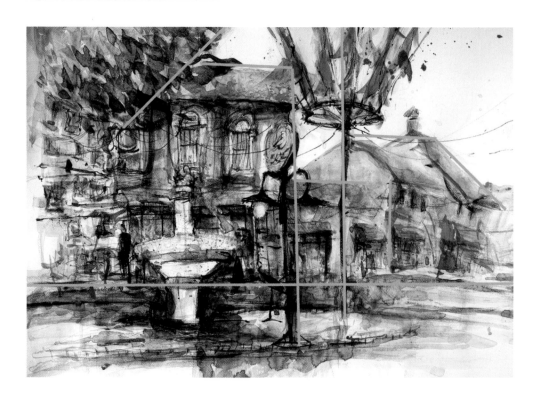

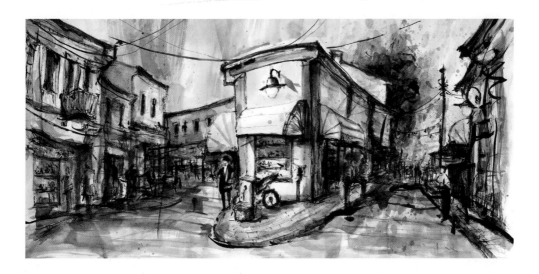

Depth

Depth can be created by overlapping objects, using perspective or diagonals to create a path, having multiple layers between the foreground and background, and altering the size of the object as it moves further away into the distance.

URBAN PULSE
BY SHARMAINE KWAN
MEDIUM: OIL ON CANVAS

To portray the busy streets of Hong Kong at night, I used the form of blocks to depict shop signs, building lights and traffic. The play between surface and depth is made through layering, and there is a variation in density between empty space and clustered details.

Depth in Digital Painting

Getting realistic depth using digital software is essential, otherwise your scene will look very one-dimensional. The examples here will give you some tips and tricks on how to achieve this.

TRAINSPOTTING BY DAVID COUSENS
PAINTING APPLICATION: PHOTOSHOP

images with a flat viewpoint can achieve a feeling of depth by making clear distinctions between the planes things exist on. The children are rendered sharply, the train's heavy motion blur defines the midground, and the background buildings are simple shapes

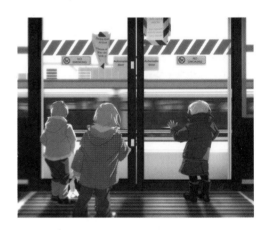

OUTPOST
BY DAVID COUSENS
PAINTING APPLICATION: PHOTOSHOP

Depth can be suggested by the level of detail you paint into a scene. Images closer to the viewer should be sharper and have more detail, and things further away, such as the rocky outcrops here, should have almost no detail.

SHOPPING
BY DAVID COUSENS
PAINTING APPLICATION: PHOTOSHOP

I like using depth of field to control focus. Here, the girl becomes the focus of the image by blurring everything else around her: the trolley is blurred in the foreground and the shopper is rushing past.

MINKEE
BY DAVID COUSENS
PAINTING APPLICATION: PHOTOSHOP

Even in a simple image, you can get a sense of depth. Here I simply painted the silhouette of the character and applied a gaussian blur to show the distance of the person looming towards the creature.

A FLORAL SCENE FOR ANNABEL
BY MATTHEW EVANS
MEDIUM: ACRYLIC ON CANVAS

The path running up into the centre of this painting helps the eye to travel into the scene, giving it a sense of depth, as well as providing a natural division between the flowerbeds on the right and the area of trees to the left.

step 1

The first stage was to establish the main sections of flowers and trees with a broad coverage of colour applied quickly. The colour of the flowers and trees was very bold and acrylic is a good choice of medium, as the pigments available are so vibrant. The covered canvas makes a good base to build on extra texture and floral detail.

step 2

The path is now a lot clearer; some of the floral colours have been picked out in the grass and the trees help to add colour harmony throughout the scene. I used a stippled effect to pick out the individual leaves in the trees and the shape of the flowers.

Final Painting

As I worked towards the finished painting, I added thick blocks of colour for the main bank of red flowers, and completed the scene with white and yellow to give a variety of floral colours in the foreground. This added to the overall impression of a colourful spring scene, with a variety of colours complementing and enhancing each other.

Start Painting

USING COLOUR

Colour is an important feature as it conveys the emotions and mood of the painting as well as your interpretation of the subject. It can be used to create harmony or contrast, depending on your selection of cool or warm colours.

Colour Theory

The three main colour categories are primary colours (red, yellow and blue), secondary colours (green, purple and orange, each made by mixing two primary colours) and tertiary colours (a primary colour mixed with a secondary colour). The colour wheel (shown below) is a useful reference tool for artists that can assist you when you are trying to choose the best colours for your painting, or wanting to mix your own blend of colours.

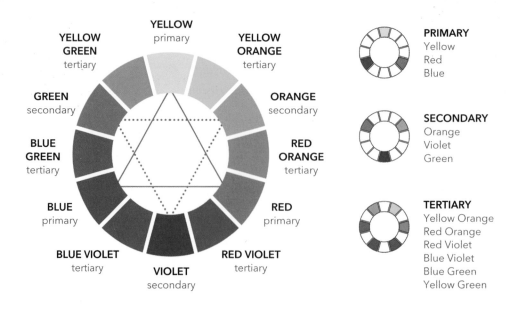

YELLOW primary

YELLOW GREEN tertiary

YELLOW ORANGE tertiary

GREEN secondary

ORANGE secondary

BLUE GREEN tertiary

RED ORANGE tertiary

BLUE primary

RED primary

BLUE VIOLET tertiary

RED VIOLET tertiary

VIOLET secondary

PRIMARY
Yellow
Red
Blue

SECONDARY
Orange
Violet
Green

TERTIARY
Yellow Orange
Red Orange
Red Violet
Blue Violet
Blue Green
Yellow Green

Complementary Colours

Complementary colours are on opposite sides of the colour wheel and can create contrast as well as being used to tone down a colour when mixing paint. For example, you may use blue with orange (as shown right) or purple with yellow.

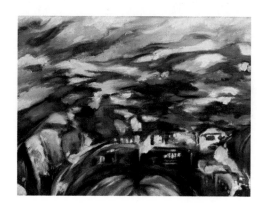

Warm and Cool Colours

Warm colours generally refer to yellow, orange and red, whereas cool colours refer to blue, green and purple. However, there are also warm and cool versions of each colour, such as a cold yellow and a warm yellow, as shown here: cool yellow on the left and warm yellow on the right.

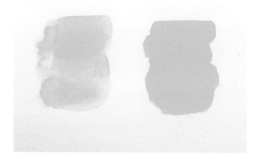

TEA SET
BY SHARMAINE KWAN
MEDIUM: OIL ON CANVAS

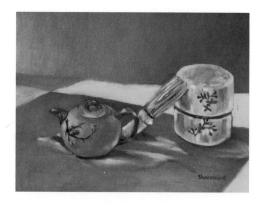

This still-life oil painting uses a limited palette of warm harmonious tonal colours. The shadows were painted with these colours as well and I applied dashes of white and yellow to highlight specific areas of the objects.

CRIMSON MACAW
BY SANDRA TRUBIN
MEDIUM: ACRYLIC ON CANVAS

Acrylic paint is fantastic to use when you want to achieve a vibrant, vivid result.

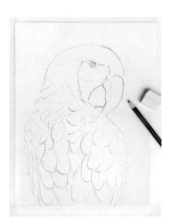

step 1

I made a quick sketch of the Crimson Macaw on taped-down canvas paper. Graphite blends into the first layer of paint, so it's important to not press hard on the pencil.

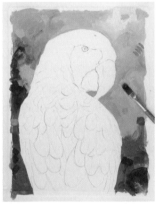

step 2

Using a flat brush, I painted the background with quick brushstrokes. I like using craft-type acrylic paint because it is liquid, easy to work with, and has a matte finish when it dries.

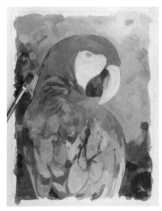

step 3

I added the first layer of paint to the macaw, keeping colours bright and not too light or dark. The macaw in my reference photo has ruffled-up feathers which gave me a lot of definition to each feather to work with.

Step 4

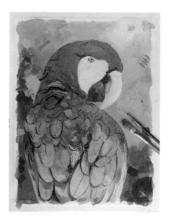

Using a fine brush, I outlined the feathers with a dark purple colour. (I prefer to avoid black to keep my painting colourful.)

Step 5

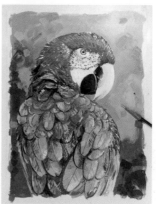

A lot of different brushstrokes can be done with the same brush if the amount of paint picked up and pressure used varies. Adding a bit of water to the paint makes it easier to make very thin lines.

Final Painting

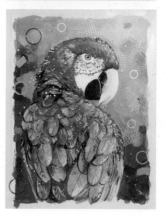

I used different meshes as stencils to make interesting pattern marks, adding some splatters and circles made with caps to the background to make it more playful.

using Digital Colour

There is an almost unlimited choice of colours available to the digital artist, so it is important to understand the basics of colour theory previously described in order to choose the right combinations for your artwork.

ALEX-VAUSE
BY DAVID COUSENS
PAINTING APPLICATION: PHOTOSHOP

A limited colour palette can make images stronger and more striking than using colours that would be accurate in real life. Consider using colours that are related to the theme for added impact.

DADDY'S THINGS
BY DAVID COUSENS
PAINTING APPLICATION: PHOTOSHOP

Choosing colours based on emotion rather than what they were in reality is something I like doing. The warmth on the right side of the room is bright and optimistic, which is complemented by the turquoise door.

STANDING WAITING
BY DAVID COUSENS
PAINTING APPLICATION: PHOTOSHOP

Although I often like using vibrant colour palettes, muted colours are sometimes what works for an image. In this case, the clothes were fairly desaturated so using an almost grey background made sure it didn't compete with the model.

SAY YES MORE
BY DAVID COUSENS
PAINTING APPLICATION: PHOTOSHOP

For this portrait of Danny Wallace, I wanted to reflect the positive outlook from his book *Yes Man*. The most positive, cheerful and upbeat colour is yellow, so I made this the predominant colour of the illustration.

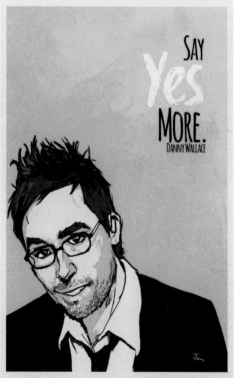

Building Digital Colour

Here, we look at how digital artist Siris Hill created skin colour using Photoshop for his piece 'Ashes', which can be seen on pages 155–59.

observe the various colours. I'm keeping to warm skin colours for this layer; I will then paint colder layers on top which will blend together and create nice transitions in the skin.

Getting Skin Tone Right

Even one skin colour has many different shades and tones if you look at it closely. Getting accurate tones and enough variation throughout the form is important. To this end, use good reference imagery so you can

Using Glazes

If you struggle with colour, it is possible to work in black and white and then glaze colour on top, keeping the values intact. To do this, create your painting in grey tones and then make a new layer on top and set the blending

mode to overlay. You can create many of these layers and build up colour slowly, mimicking colour glazes in traditional oil paintings.

You will be able to see that here, I have become more free with my colour palette to create a variation in the skin. I am using lots of blues, greens, pinks and yellows, which I build up over various layers like glazes.

Working in Planes

The body is particularly tricky to paint as it is easy for anyone to notice when something is anatomically incorrect: we all know what humans look like, after all. Try to break each section down into planes and use confident long brushstrokes to represent that plane. Focus firstly on the value, and then glaze colours on top to get the correct skin tone.

using Fluorescent Colour

As a contrast to the colours on the colour wheel, using a combination of black, white and neon colours in your work can be startling and effective.

HOW TO PAINT NEON LETTERS
BY SHARMAINE KWAN

Step 1

For this example, I used black paper as the starting point. Using white gouache or a white gel pen, draw the outline of the text or design. For complicated forms, you can use a white colour pencil to lightly sketch it out first.

Step 2

Wait for it to dry. Next, use vibrant fluorescent poster colour and either paint on top of or around the white outline, depending on the type of glowing effect you would like.

Step 3

Clean the brush and apply water around the edges of the paint to let the glow blend into the background.

Step 4

Another effect is to dilute the paint with water and apply it inside the text for the inner glow. Patterns around the text can be painted over lightly with fluorescent colour to cover the bright white colour and not distract attention from the text.

Final Painting

TEXTURE & LAYERS

Adding the impression of texture and layers can enhance the overall aesthetic of your painting, as it introduces a variety of different surfaces. You can convey the material of your subjects, which will help to make your painting visually stimulating.

Creating Textures

Physical textures can be made using the impasto technique, applying thick oil paint or acrylic paint. Another method is creating the illusion and impression of texture by observing and imitating the surface of the subject.

USING SALT IN PAINTING BY SHARMAINE KWAN

Salt can be used with watercolour to create interesting effects and textures for backgrounds and skies. Here, I will use it to create the impression of flowers.

step 1

First, paint a layer of water and then drop in colours of your choice.

step 2

Whilst it is wet, sprinkle salt on top in clusters as you visualize the positions of the flowers.

step 3

Wait for it to dry as the salt absorbs the moisture. Next, paint some dots in the centre of the flowers and darken areas around the border of the painting.

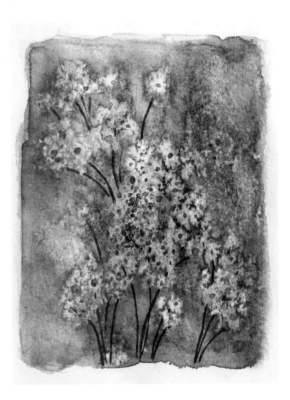

Final Painting

Allow it to dry before adding details such as the stalks and petals.

Layering

Layering can be used to make the painting more interesting by overlapping and revealing areas as well as building up the surface to enhance the visual effect. An example would be adding refined details on top of a coloured wash.

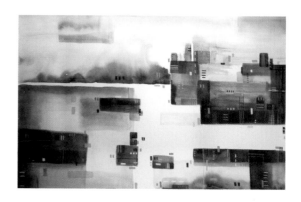

SALE
BY SHARMAINE KWAN

MEDIA: WATERCOLOUR AND POSTER COLOUR ON PAPER

This painting is inspired by Salvador Dalí's surrealist ideas and was exhibited at the Rybnik Cultural Centre in Poland. A watercolour wash was used for the background and poster colour to paint the other details. Linocut printing was used on the top layer in various colours, which helped to integrate the different sections.

CITY THAT NEVER SLEEPS
BY SHARMAINE KWAN
MEDIA: ACRYLIC, EMULSION AND GLITTER ON PAPER

This is an impression of the pulsing energy of Hong Kong at night painted with acrylic, emulsion and glitter on paper. I painted the black background first, followed by the rectangular strokes using diluted translucent acrylic. I used more opaque and vibrant colours for the smaller details on the top layer and mixed in silver glitter.

Textures in Digital Painting

Just as with traditional methods, it's important to introduce different textures into your artwork to reflect the subject of the painting, and to set the tone for the viewer. Here are some examples of how to do that.

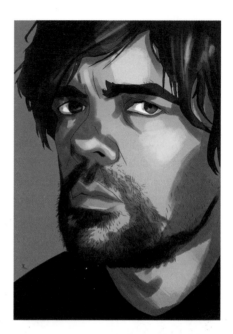

PETER DINKLAGE PORTRAIT
BY DAVID COUSENS
PAINTING APPLICATION: PHOTOSHOP

Textured brushstrokes contrast nicely with the simplicity of the background, drawing our attention to the subject. The human eye is drawn to detail, so use more detailed brushstrokes where you want people to focus.

SAUL GOODMAN
BY DAVID COUSENS
PAINTING APPLICATION: PHOTOSHOP

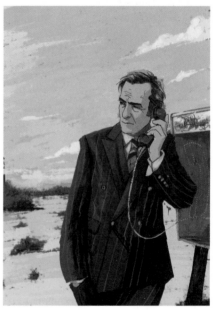

The sharp line work in this image draws our attention to the character, where the less defined brush work helps the background recede into the distance. There is greater tonal variation in the close-up textures.

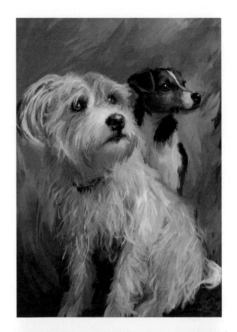

THE DOGS
BY DAVID COUSENS
PAINTING APPLICATION:
COREL PAINTER AND PHOTOSHOP

To get a sense of the different textures of both dogs' fur here, I painted the smaller dog's fur all on one layer, while painting the larger dog's hair on several layers to show the depth and mass of hair.

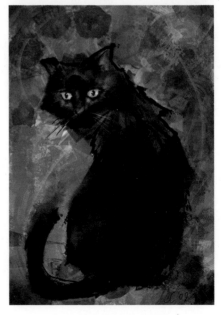

SHIVER
BY DAVID COUSENS
PAINTING APPLICATION:
COREL PAINTER AND PHOTOSHOP

I went for a mixed-media effect here, using a photo of the cat's face as an image stamp in Corel Painter which contrasts nicely with some of the more traditional-looking painterly effects.

MAGMANEQUETHRONI BY DAVID COUSENS

PAINTING APPLICATION: PHOTOSHOP

step 1

Choosing your colours carefully helps establish the mood of the piece. Knowing lava is bright yellow, choosing its complementary colour purple means the image will look dynamic and makes the creature seem menacing because purple is often associated with death.

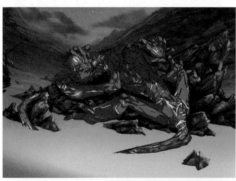

step 2

Add the magma glows flowing through the creature by creating a new layer on top of the line work. Double-click it on the Layers palette and set it to 'outer glow', using an orange colour and painting with a small yellow airbrush.

step 3

The purple rim lighting is applied to a Clipping mask layer above the line work (Layer Settings: Linear Dodge, Opacity: 80%). Paint with light pink. The secondary source of lighting makes the creature feel more three-dimensional and real within the scene.

Final Painting

Make the colours more intense by creating a Layer at the top of the Layers stack and setting its Blending Mode to Overlay. Use the Radial Gradient Tool (settings: 25% Opacity, Foreground to Transparent) and apply orange and purple glows where appropriate.

EXIT I
BY GIOTA PARASKEVA
MEDIUM: ACRYLIC

This abstract is a fun way to experiment with colour layering and the use of an acrylic glazing medium.

Step 1

To start with, I drew a composition of overlapping rectangles.

Step 2

I mixed yellow with a little white and applied a base colour on to the entire canvas with a flat brush.

Step 3

I mixed a small amount of acrylic colour with an acrylic glazing medium and then applied thin layers on to the rectangles with a palette knife. A small quantity of colour is enough for a vibrant result with a transparent effect.

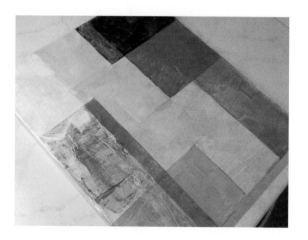

Step 4

I applied thin layers of paint to the rectangles until I was satisfied with the result. I switched my movement so as to achieve an interesting texture. Every layer has to be completely dry before applying another one.

step 5

I moved to the yellow area, mixing a little bit of colour with a glazing medium. I applied the colour with a palette knife so as to keep the edges of the rectangles sharp.

step 6

I smoothed the colour out with my brush.

step 7

I repeated this on all the yellow areas.

step 8

I highlighted and enhanced some areas to perfect the painting.

Final Painting

WASHES

Washes are translucent layers of paint that can overlap areas you have painted whilst allowing details to remain visible. Washes contribute to the overall tone and can be applied to build upon certain parts as well as creating different shades of one colour.

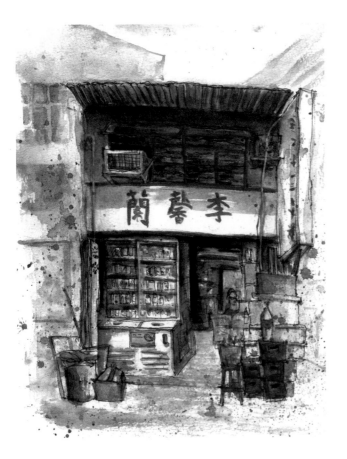

Watercolour Washes

I painted 'Traditional Convenience Store' on location using watercolour and a black ink pen. To convey the history and atmosphere of this traditional convenience store, I toned down the saturation of the colours to grey and brown. I splattered paint around the edges and simplified the adjacent buildings to a light wash to not distract attention from the main focus.

TENBY HARBOUR
BY MATTHEW EVANS
MEDIUM: WATERCOLOUR ON PAPER

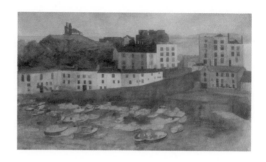

Step 1

The main areas of the buildings were lightly sketched and a general watercolour wash was used to pick out the green of the headland, which in turn pushes forward the lighter-coloured houses. I checked the perspective and altered as I painted, and the watercolour layers gradually became stronger. The boats were added using a watercolour wash on the water, enabling me to pick their shapes out carefully.

Final Painting

The windows in the buildings were picked out in white acrylic, as were the boats' masts. I added a watercolour texture to the harbour wall and the trees on the headland. Individual details and colours were added to the boats.

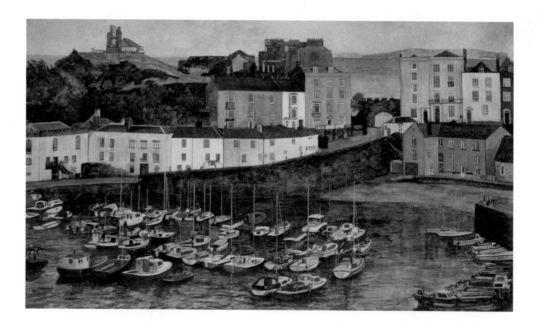

HOW TO PAINT RUST BY SHARMAINE KWAN

For this tutorial, I chose to paint a rusty Chinese postbox, building up the density of colour with numerous watercolour washes.

Step 1

The first step is to paint a light grey wash with the basic form to build on to later.

Step 2

Whilst it is still wet, drop in rusty colours such as brown, orange and blue. Allow these colours to spread and bleed to create a rusty impression.

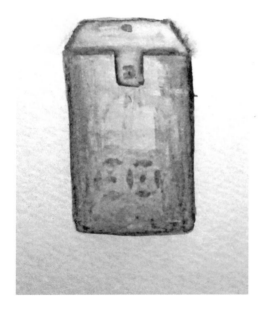

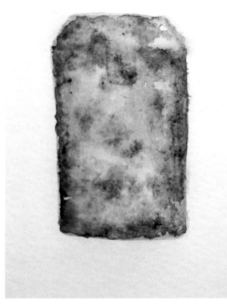

Step 3

Add some darker tones as the watercolour will become a lighter shade after it has dried.

Final Painting

Continue adding details and darken the tonal values of the edges for higher contrast.

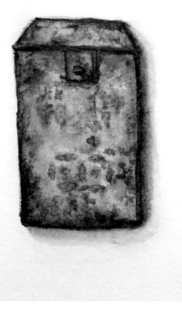

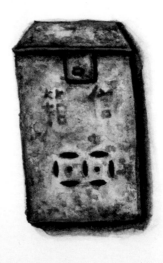

HOW TO PAINT BRICKS
BY SHARMAINE KWAN

For this tutorial, I will be using watercolour,
sepia ink (waterproof), a flat brush, a pointed
round brush, a water spray and a bamboo dip
pen, and will show you how you can achieve
interesting textures using a watercolour wash.

 step 1

Using a flat brush, paint the bricks, following
this alignment and pattern with brown
and red watercolour. Depending on the
material of the bricks, you can also add
grey, green or orange tones.

step 2

Next, draw lines around the bricks using sepia
ink with a dip pen (either a metal nib or a
bamboo dip pen is fine). For neater bricks,
use straight lines and for a roughly built brick
wall, outline each individual brick loosely.

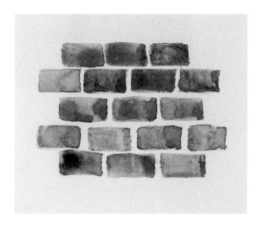

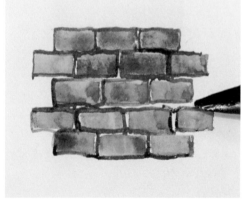

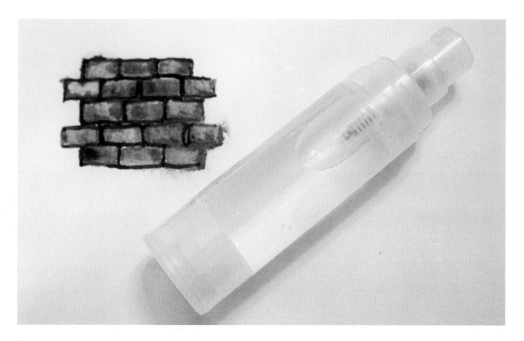

Step 3

Whilst the lines are still wet, spray a fine mist of water to create this textural bleeding effect.

Final Painting

To add some depth, mix a dark brown with purple and use a pointed round brush to paint the gaps and shadows between the bricks. You can also use this colour and dilute it with water to paint over certain areas of the bricks to create some shading on the surface.

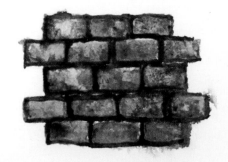

Bringing Your Painting To Life

LIGHT & SHADE

The use of light and shadows can bring your painting to life and be used to highlight areas, create contrast and convey the time of day. Things to consider include the direction and intensity of light to create your desired effect and how it may affect the saturation and tone.

Light & Shade Basics

The brightest point is called the highlight and the areas around it are the halftones. The area that is away from the light source is the core shadow and the darkest part under the object is the cast shadow.

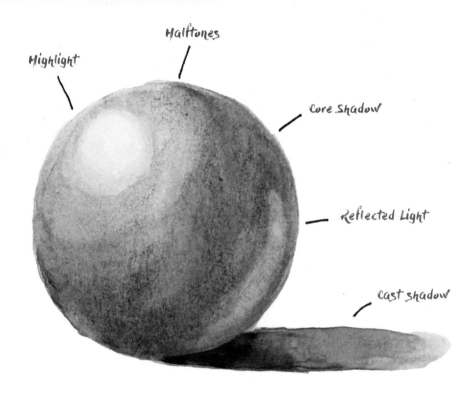

Highlight

Halftones

Core Shadow

Reflected Light

Cast shadow

Colour of Shadows

Shadows are usually a grey tone, but they also contain the complementary colour of the light source. If the sunlight is yellow, then the shadow will have a purple shade.

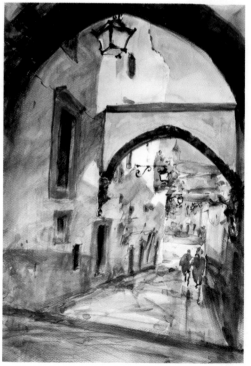

ALLEYWAY
BY SHARMAINE KWAN
MEDIUM: WATERCOLOUR ON PAPER

This watercolour painting featuring the streets of Portugal uses a dry brush technique with repetitive quick strokes to create a sketchy, rough look. There is a focus on light and shadow, and the composition with the archways framing the image helps to create depth, directing the viewer into the alleyway.

Quick Tip: When you are looking at your scene or subject, try squinting your eyes; you will see a lot less detail, but it is easier to see the values and shapes.

HOW TO PAINT TREES BY SHARMAINE KWAN

In this tutorial, I would like to show how to create the effect of light and shade in foliage. I mainly used a bristle brush to create the impression of leaves on the tree and I used a round pointed brush to paint the branches.

Step 1

Firstly, dab yellow watercolour with the bristle brush for the top areas that are in the sunlight. Next, bleed in a bit of light green underneath the yellow.

Step 2

Continue to use different darker shades of green and brown for areas that are in the shade. This will add some depth to the tree.

step 3

Finally, wait until it has dried before adding the branches with a round pointed brush.

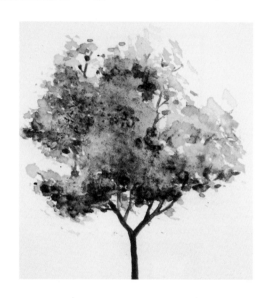

Trees around a Pagoda

In this example, you can see how effectively dark and light paint has been used to highlight foliage both in and out of the shade.

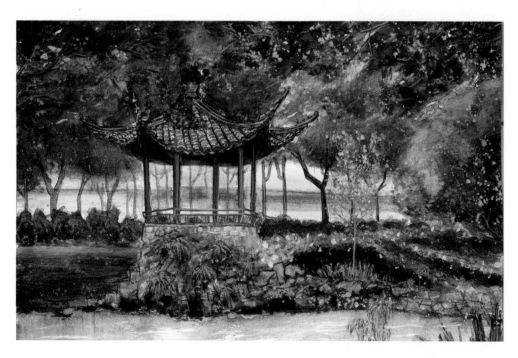

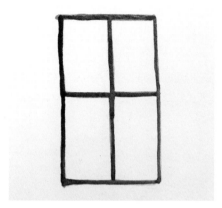

HOW TO PAINT GLASS
BY SHARMAINE KWAN

In this tutorial, I used watercolour with gouache to show how it is possible to create the effects of light and shadow on glass; broken glass, to be more precise.

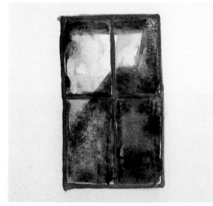

Step 1

First of all, I used a pointed round brush to paint the outline of the window frame.

Step 2

I then painted the interior of the window by keeping it simple and placing the focus on light and shadow to create depth.

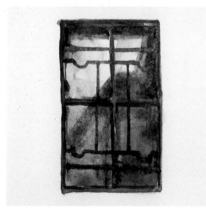

Step 3

After the background layer had dried, I added details like the lines of the window frame.

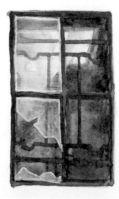

step 4

Using white gouache, I thinly painted over the background layers to create a translucent effect. (You must make sure the brush is not too wet and apply this layer lightly so as to not disrupt the bottom layers.)

Final Painting

To highlight the edges of the glass, I added some white to the outline and darkened certain areas of the background.

Broken Glass in Window Panes

Here, you can see how effectively the technique described above has been put into practice in this example.

Light & Shade in Digital Painting

Here, we see how light and shade has been used in a variety of different ways in dramatically different types of paintings. Light and shade can be used to change the mood of an artwork or to highlight a particular element within it.

WHAT'S IN THE BOX? BY DAVID COUSENS
PAINTING APPLICATION: PHOTOSHOP

Your eyes are always drawn to the highest contrast in an image first, so this should be your main focal point. The character's eyes are where we want the viewer to look to understand the emotion of the image immediately.

REG BY DAVID COUSENS
PAINTING APPLICATION: PHOTOSHOP

Our eyes are only capable of viewing a certain value range, so when there's overexposed light, I avoid painting with too many colours and instead use some very dark shadows to simulate this limitation, making the image feel more real.

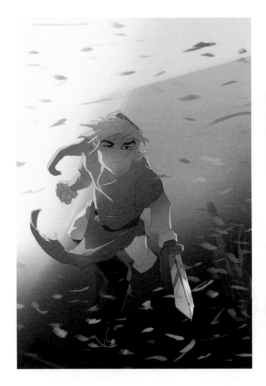

LINK AT THE
FOREST TEMPLE
BY DAVID COUSENS
PAINTING APPLICATION: PHOTOSHOP

Lighting is very important in setting the mood of an image. In this case, I made the background light bright and optimistic to create a dramatic contrast against the dark, foreboding foreground that the hero is looking at.

SPACE PIRATE
BY DAVID COUSENS
PAINTING APPLICATION: PHOTOSHOP

Light doesn't have to be incidental, it can be a major feature in your images. I gave the space pirate a laser cutlass and glowing shoulder armour to help him stand out in front of the impressive celestial sky.

MOVEMENT

Introducing movement into your painting can make it more alive and dynamic. For example, you can use expressive brushstrokes to convey the impression of people in action or the movement of water and wind.

using Brushstrokes

The speed of your brushstrokes can help to convey movement in your painting. Practise capturing the movement of people, cars and nature using quick and loose brushstrokes, and you can also exaggerate it to enhance the effect of motion.

Visual Movement

Another type of movement that is important is using form, colour and composition to guide the viewers' eyes around your painting. Use

HOUSE
BY SHARMAINE KWAN
MEDIA: WATERCOLOUR & INK ON PAPER

This watercolour painting was done en plein air in Macedonia, and used speed to direct my instant impression of the location on to paper. There is a combination of accuracy with looseness and the colours are embedded around the different areas of the painting for cohesiveness. The details were painted last with black ink using a bamboo stick.

repetition and create focal points of interest to sustain your viewers' eye movement and attention, as in the picture above.

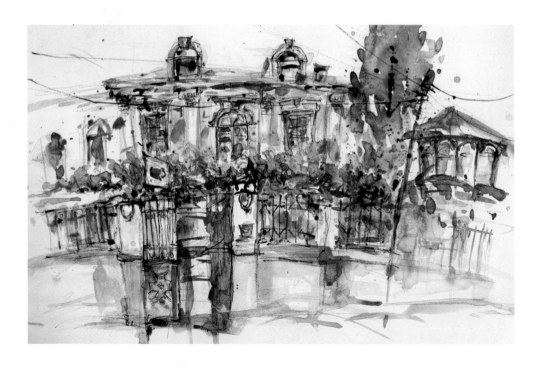

Movement in Digital Painting

Trying to convey the idea that a subject has been captured in the middle of a dramatic moment or scene carries as many obstacles for the digital painter as for the traditional artist. Here are a few examples that give tips and tricks from a digital artist on how to bring your artwork to life.

CYBERBOTS
BY DAVID COUSENS
PAINTING APPLICATION: PHOTOSHOP

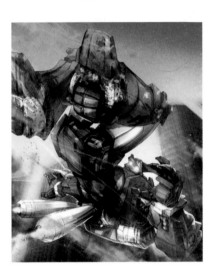

This image yells excitement and action! The multiple bits of debris and smoke are all blurred out of focus as they shoot past the camera, which also lets your brain know to focus on the robot hurtling through the sky!

PHONE CALL
BY DAVID COUSENS
PAINTING APPLICATION: PHOTOSHOP

Because we can tell that the chain has literally just snapped away upwards from the anchor on the floor it leaves us wondering what is happening in the scene and makes us feel the world is alive with mystery.

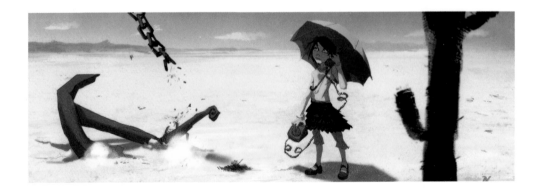

SHELL SHOCK
BY DAVID COUSENS
PAINTING APPLICATION: PHOTOSHOP

The strong radial motion blur applied to this image makes us feel that we are watching the actual moment that the turtle's shell is shattering apart because our brains can't take in all of the detail of the event!

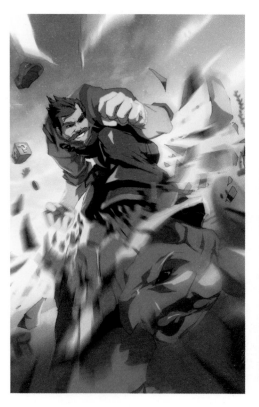

ROM
BY DAVID COUSENS
PAINTING APPLICATION: PHOTOSHOP

Conveying movement in an image can be done by showing both things that are currently happening, and indicating things that are about to, like the water dripping off the tentacles all over the place and the gun about to shoot.

GEARS OF WAR BY DAVID COUSENS

PAINTING APPLICATION: PHOTOSHOP

step 1

When I first started this image, I only knew I wanted to have the soldier ducking for cover in some ruined setting, so I initially drew him and started to paint the background with colours from his palette.

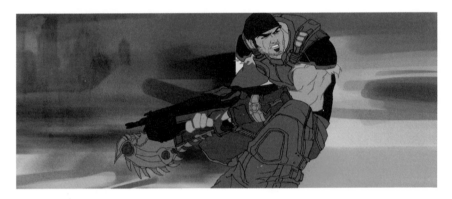

step 2

I started to paint in layers of crumbled building over one another. I saved myself time by not going too crazy over details at this point because I decided there would be lots of debris flying through the air!

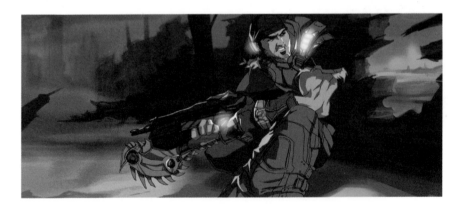

Step 3

Here, you can see why a lot of background detail wasn't important for the scene – too much detail can be overpowering. You notice movement before static items, so here we concentrate on gunfire and rubble erupting!

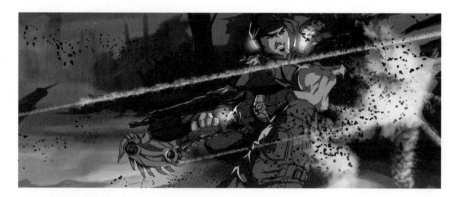

Final Painting

Now we get the full impact of the scene with blurs and blood thrown in for good measure. I also colour-graded the image, making the sky darker and sand richer with gradients on an Overlay layer.

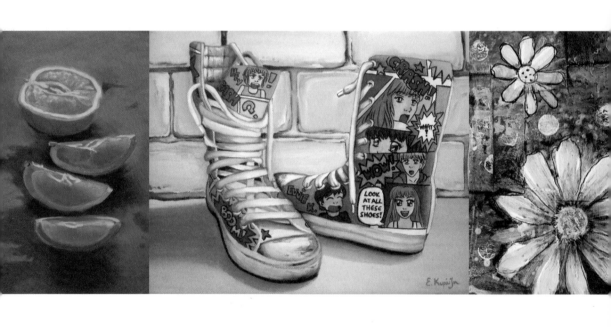

Contemporary still Life

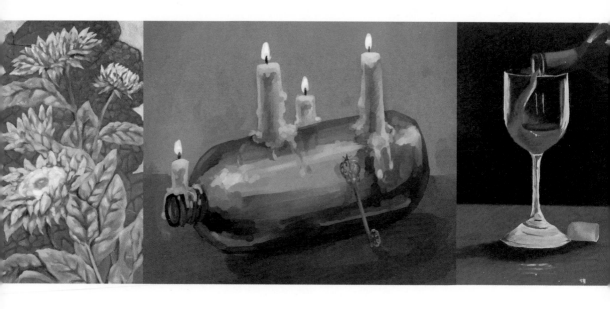

PROJECTS

The focus of still-life painting is the observation and representation of your subject. Pay attention to the form, details, colour, light, material and size. This genre encompasses a wide range of subjects and this chapter will give you inspirational ideas from a varied group of artists.

BLOOMING
BY SHARMAINE KWAN
MEDIUM: WATERCOLOUR ON PAPER

This watercolour painting features the layering of multiple washes. I first applied a yellow and orange wash as the background and then I painted the lotus. Next, I added the green wash, small details, and played with negative forms.

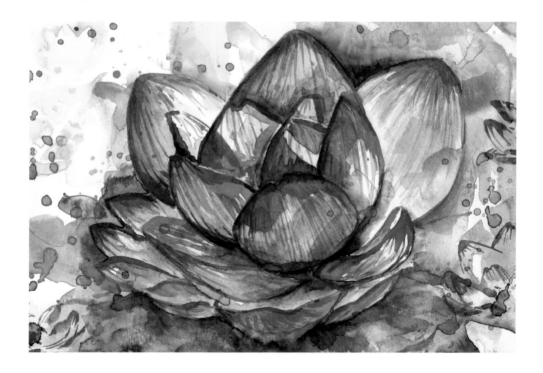

RED APPLE BY DANI HUMBERSTONE

MEDIUM: OIL ON CANVAS

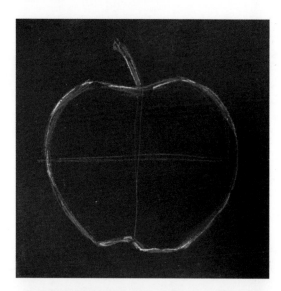

step 1

Paint a ground (background colour) on to a prepared canvas; I used a mixture of Burnt Umber and Mars Black. Then using a white pencil, I sketched in the apple shape. Draw your fruit in using straight lines to start, then sketch in the curves, etc., once you have got the basic outline.

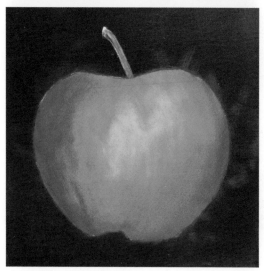

step 2

Using a flat brush, I started painting in the colours of the apple, noting the highlights and the shadows. Keep in mind the rounded shape you want to end up with.

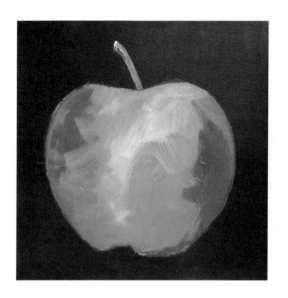

step 3

I let the oil paint dry off a bit, then gently blended the colours together using a very soft brush: an old split brush works well for blending if it is not too hard.

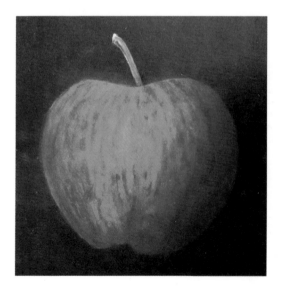

step 4

Next, I started adding in some detail, in this instance the darker red stripes and tiny spots; again, don't forget to keep the overall shape of the apple in mind when you are doing this.

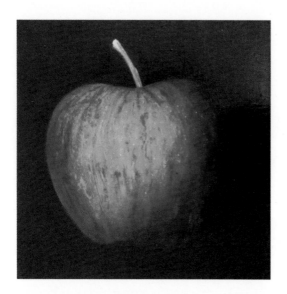

step 5

I blended the details in very carefully so they softened but did not disappear. Then I repeated the adding of detail, followed by blending. In fact, I kept going with the detail until I was happy.

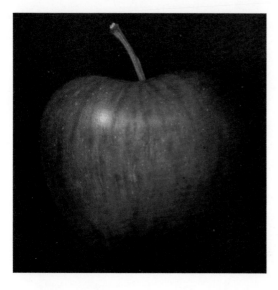

Final Painting

I finished by repainting the background, then 'disappeared' the right-hand lower portion of the fruit by blending the background colour over the area I wanted to darken. Lastly, I added 'soft' highlights and finished with a small area of a brighter white which really made my Red Apple pop!

Quick Tip: You can put a glaze over the highlights to reduce the whiteness.

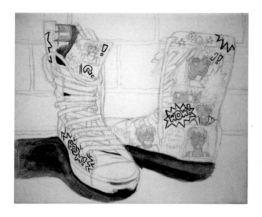

LOOK AT ALL THESE SHOES!!!
BY EVVIE KYROZI
MEDIUM: ACRYLIC AND
TEMPERA ON CANVAS

step 1

I started by making a sketch using a pencil. After defining the direction of my light source, I added a thin layer of colour as a guide for the shadow and worked a little on the comics part of the shoes to get a feel for the rest of the painting.

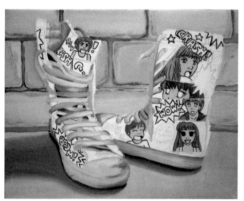

step 2

After the first layer of the background was completed using tempera, I started working on the shoes using acrylic. Always keep in mind your light source: in this case, my colours will be darker on the left and brighter on the right.

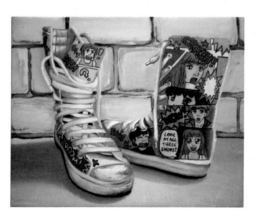

step 3

I finished the first layer of colour on the shoes. Next, I painted a second layer of the background, enhancing the highlights and shadows, and also made small changes to the brick wall.

Final Painting

For the final step, I added even more dirt on to the shoes and worked on the darker parts, as well as on the painting overall. Speech bubbles were filled, minor alterations were made, errors were corrected and my painting that combined fashion with comics was ready!

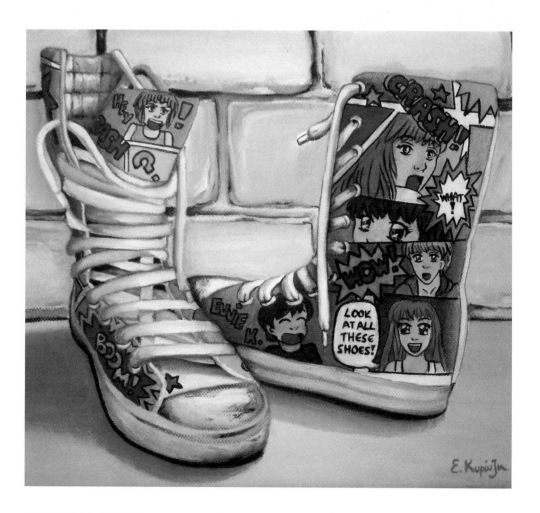

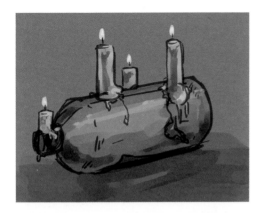

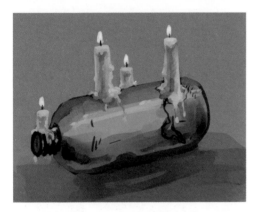

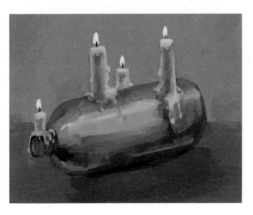

BOTTLE
BY DEMI ZWERVER
PAINTING APPLICATION: PAINT TOOL SAI

step 1

I sketched the bottle and candles, and roughly filled in some colour. I work only on one layer, so I merged the sketch and colours and will have to paint over the guidelines later.

step 2

Here, I started working out the candles, giving them depth and painting over the guidelines so they will not be visible in the finished piece. I did a little work on the bottle here too.

step 3

The guidelines are now completely gone. I tried to make the glass as realistic as possible. I added more background, and edited some details.

Final Painting

I used the program's filter to achieve a little more contrast and saturated colours. After leaving it for a few hours to clear my mind, I also added the key to give the painting that little bit extra.

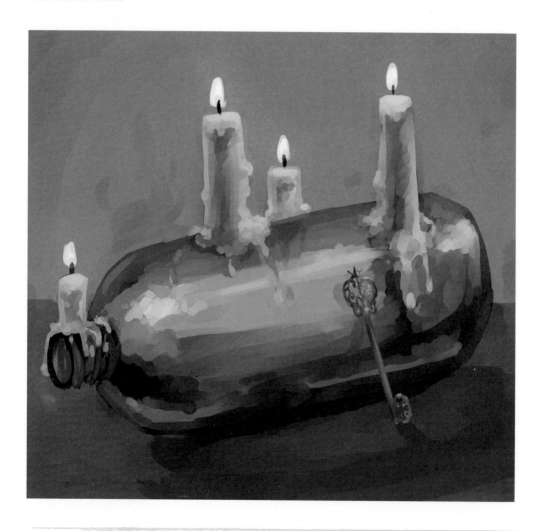

ONION AND MUSHROOM
BY JULIE NASH
MEDIUM: WATERCOLOUR

Step 1

I arranged my onion and mushrooms and made a large pencil drawing on watercolour paper (A3, 300mgs).

Step 2

I used a size 16 brush and painted thin washes of Yellow Ochre, with a Burnt Sienna and Crimson wash over the darker areas of the onion and mushroom caps. I left white paper for the onion's highlights and the white vellum on the mushroom. I then used very thin washes of these colours over the mushroom stem and gills. I used a cool, thin mix of Burnt Sienna and Ultramarine for the cast shadows.

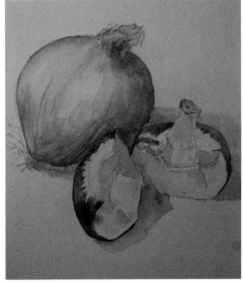

Step 3

In this step, I strengthened the tones on the onion with the same Burnt Sienna and Crimson mix. I used brushstrokes to create the effect of veins in the skin by allowing the underlayers to show in places. I darkened the Burnt Sienna and Crimson mix by adding a little Ultramarine. I used this on the shadow areas on the mushroom caps, and to suggest gills.

Final Painting

Using the smaller brushes (sizes 4 and 2), I continued building up colour and tone around the neck of the onion to suggest ridges and make it look crinkly, adding a few roots in the same way. I darkened the onion behind the mushroom. I also darkened the mushroom caps and gills to create shape and sufficient contrast with the white vellum. I added finer details, including the shadows over the gills, on the stem, under the vellum frill and the negative spaces between the onion roots. Sit back, review your work and enjoy your results.

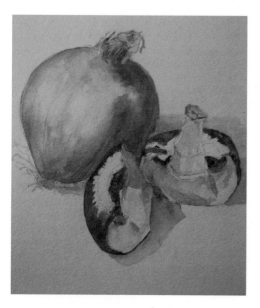

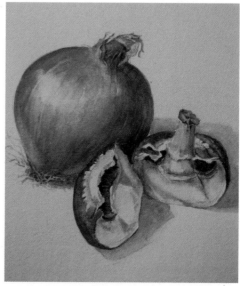

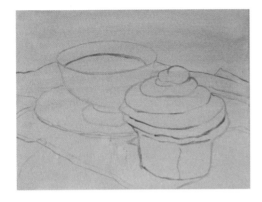

TEA AND CAKE
BY KARLA SMITH
MEDIUM: OIL

step 1

I stained my canvas to tone down the bright white. Using a Raw Sienna, I drew the outlines of the subjects for this painting.

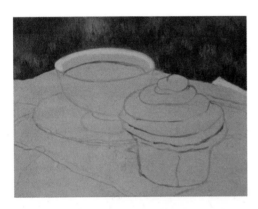

step 2

I started by painting the background. I always paint from the back to the front – dark to light. The grass in the background is Sap Green, Yellow, Mars Black and Oxide of Chromium.

step 3

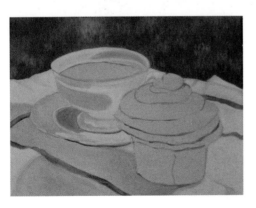

Next, I painted the base colours of the white napkin and teacup with Titanium White mixed with a touch of Payne's Gray to soften the white. The shadows were made using Payne's Gray, Mars Black and Cerulean Blue. The dark strips are where I will later paint over the stitching of the fabric; this was painted in a dark Payne's Gray.

step 4

The colour of the tea was achieved using a thinned-down Mars Orange towards the bottom and Yellow Ochre Light at the top; this needed to be very thin to look transparent. To make the chocolate frosting look as if it had been swirled on to the cupcake, I used Burnt Sienna, Van Dyke Brown, Cadmium Yellow Deep and Mars Orange. I also began the gold trim on the teacup and plate using Cadmium Yellow Orange. The cherry on top of the cake is Cadmium Red with Van Dyke Brown for the darker spots, with a touch of white for the highlight.

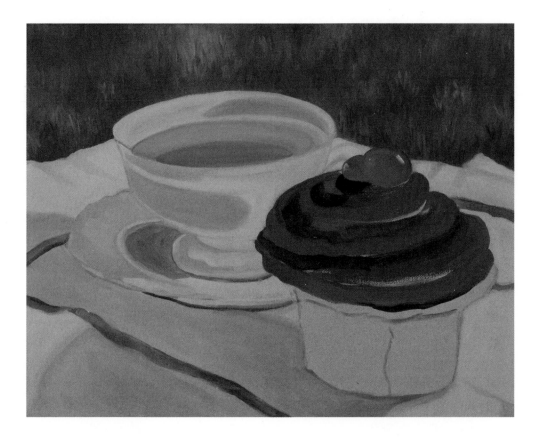

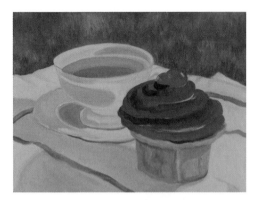

Step 5

The base of the cupcake is painted choppy to look like crumbs and texture of the cupcake. I used Naples Yellow, Raw Sienna and Van Dyke Brown, with touches of Mars Orange and Burnt Sienna.

Step 6

In this step, I started adding the embroidery on the cloth napkin. I painted the raised thread patterns in white and painted the Xs over the dark Payne's Gray strip for the border. Around the edges of the patterns, I painted a small line of dark Payne's Gray to show the raised edges of the threads.

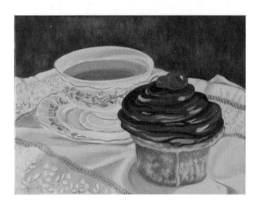

Step 7

In this step, I started painting the pattern on the teacup with soft reds: Cadmium Red and white. The green part of the pattern was made using the same colours as the grass background. I also put the finishing touches on the gold trim.

Final Painting

This step brought everything together. I looked over the details and made small additions to colour and corrections to the painting, including the design on the napkin, the teacup and the frosting.

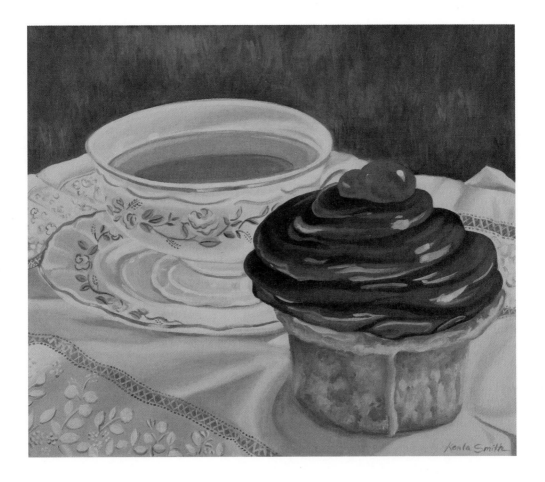

ORANGE SLICES BY JOSEPH FRANCIS
PAINTING APPLICATION: REBELLE BY ESCAPE MOTIONS

I chose Rebelle by Escape Motions as my digital painting application. It's simple, inexpensive and I like how it simulates digital acrylic. I referred to my photo while painting using the 'Irfanview' viewer set to 'always on top.'

step 1

I made a small still-life from household objects: a sliced orange on a cutting board. For my light source I used a window, because it produced a single, soft shadow for the oranges and gave them a nice glow.

step 2

I try to be simple but accurate from the start. If I'm not happy at any point with a stroke's hue, value, saturation or placement, I try to identify my error and revise. That's the beauty of the digital medium.

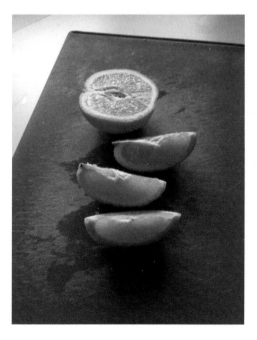

Step 3

Much of my process at this stage consists of the creative loop: where is the painting now and what stroke or erasure will move it towards my goal? The important thing is to begin. You can't steer a parked car.

Step 4

I add detail, resolving simpler forms into complex ones. I limit the complexity I see by squinting my eyes. I feel that accuracy of value and hue, painted confidently but without excessive detail, makes for a livelier, more energetic painting.

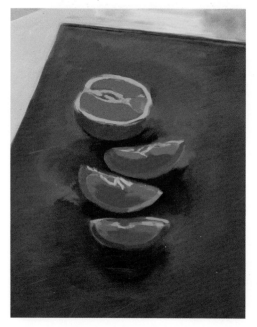
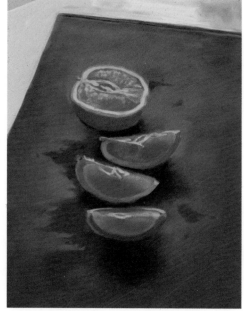

PLANT ON STONE WALL
BY SHARMAINE KWAN
MEDIA: WATERCOLOUR AND GLUE

I first applied a special mixture of glue to the areas of the stone wall, which reacts with the green and brown wash to create this textural effect. I then painted the details and gaps between each stone.

SUNFLOWER
BY SHARMAINE KWAN
MEDIUM: WATERCOLOUR

The underpainting was done with Burnt Umber and then I applied the darker tones. The lighter colours, such as the white and yellow, were painted last. Unlike the red background that uses blending, the brushstrokes of the sunflower are visible.

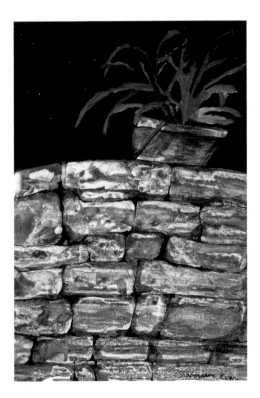

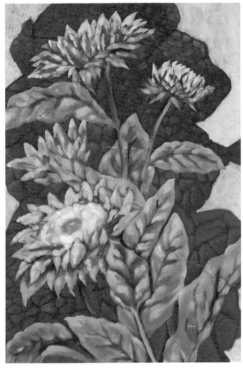

B&W FLOWER BY DEBORAH WAINWRIGHT
MIXED MEDIA

step 1

I cut up printed papers, keeping the edges straight. I laid out the papers on top of each other, sticking them down with a medium-matte medium. I used my 8 x 8 journal fort the paper. Remember to think about composition here, as it will be too late once the paper dries.

step 2

I applied a thin coat of white acrylic over the page and when it was nearly dry I applied more colour around the outer edges. I used a steel colour from a dye-based ink spray which also had some mica incorporated into it to give it some shimmer.

step 3

Using a heavy bodied white acrylic,
I started to paint a basic daisy shape:
three large and two small.

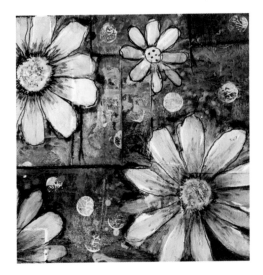

step 4

I also added some large dots in white
acrylic using a small metal cylinder with
a flat end.

Final Painting

To finish, I edged the flowers in a black ink and edged the rectangular shapes of the background papers with a black water soluble pencil.

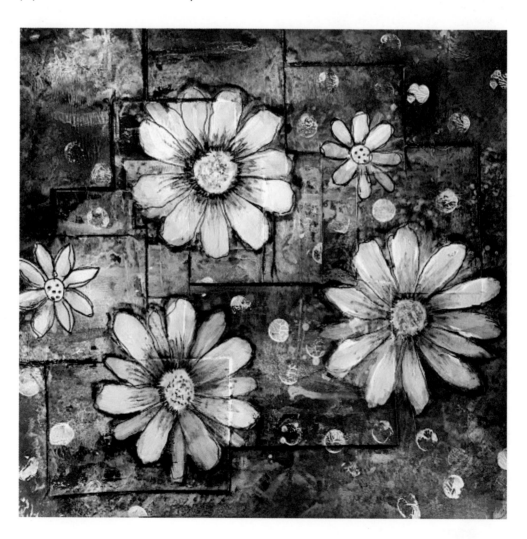

DEAR MUSIC BY DEMI ZWERVER

PAINTING APPLICATION: : PAINT TOOL SAI

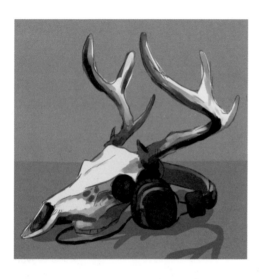

step 1

I sketched the image, then coloured the layer underneath before merging both the layers. From this point on, I usually work on only one layer, so I merged the sketch and colours, with a view to painting over the guidelines later.

step 2

Here, I smoothed and refined most of the skull and some of the antlers as well. I tried to get rid of the guidelines as much as I could.

Final Painting

The guidelines are not visible any more. I finished the headphones too. Lastly,
I edited the colours and increased the contrast.

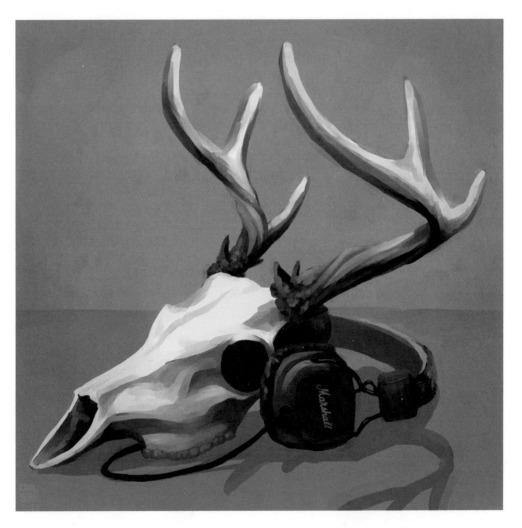

WINE GLASS BY SUZANNE CLEARY

MEDIUM: ACRYLIC

Step 1

The first step in any painting is the composition. Set up your objects on a flat surface – ideally choose a place with natural light. Forget about all the fine details and shading at this stage. Just sketch out all the basic shapes. I like to sketch lightly and freely to begin with, until the composition is set. I placed the glass slightly off centre to create more shadows.

Step 2

Make sure your paint stays in good condition – acrylic paint dries quite easily. Only squeeze a small amount of acrylic paint at a time. I started in the centre of the painting, working with the darks first. Working with the background colour helped to create the glass effect.

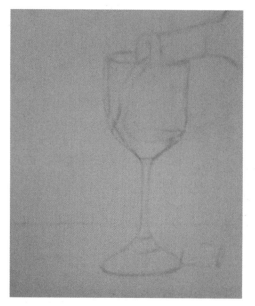

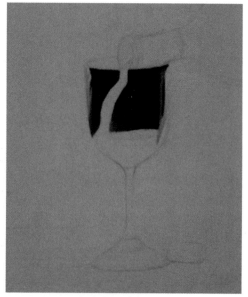

Quick Tip: As you paint, occasionally look at the image in a mirror. This can help reveal any imbalances in the painting.

Step 3

I then started to introduce more colour to the painting, using Cadmium Red for the colour of the wine. Colours do not have to be exactly as they are in real life. Shadows are key in this painting: people often automatically reach for black paint, but mix in a dab of red to tone down the harshness of the black and make it look a bit more natural.

Step 4

I worked hard with the highlights at this stage, using red paint to create the light. White is not always my first choice when it comes to creating highlights in a painting.

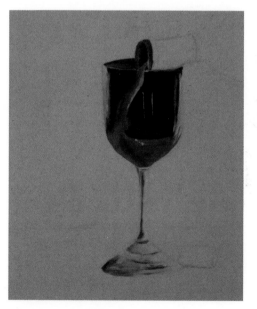

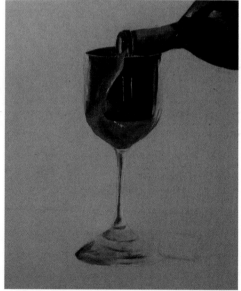

step 5

Filling in the background here made the glass come to life. You can see that some parts are completely finished, others are half finished and some, like the foreground, I am yet to begin. You can see from this how to build and lay more colours: the painting transforms from appearing flat and simple to looking three-dimensional and realistic.

step 6

I went for a really bright effect on the table, as I wanted to incorporate the same colour as the wine. This creates a flow to the painting, and keeps colours to a minimum. The most important thing at this stage is to relax and concentrate on filling in the rest of the painting.

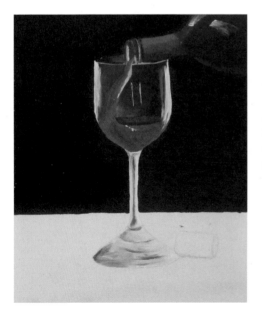

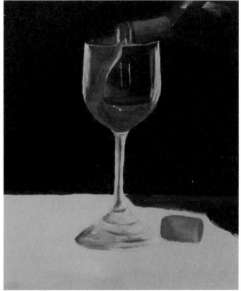

Step 7

Here, we see that the painting is nearly finished. I worked on the foreground, using layers of paint to create the shadows. At this point, I went back to the centre of the painting, adding more highlights and shadows to create a photorealism effect. I used a dry brush and paint undiluted by water; this created a strong current of colour on the canvas.

Final Painting

Before completing the painting, I worked in a few more highlights and shadows. The last thing to do is to sign your painting.

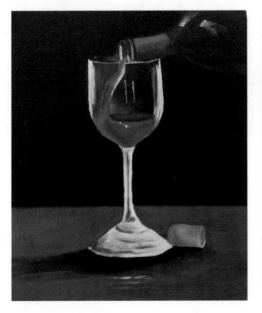

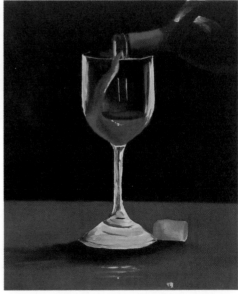

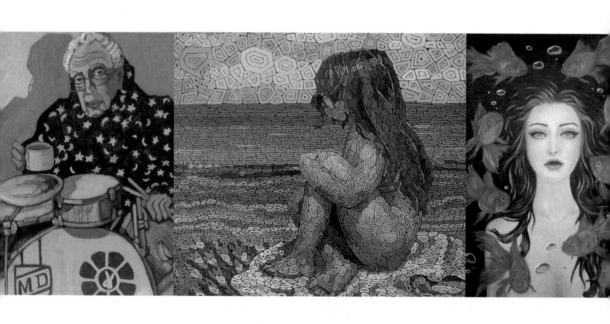

Modern Portraits & Figures

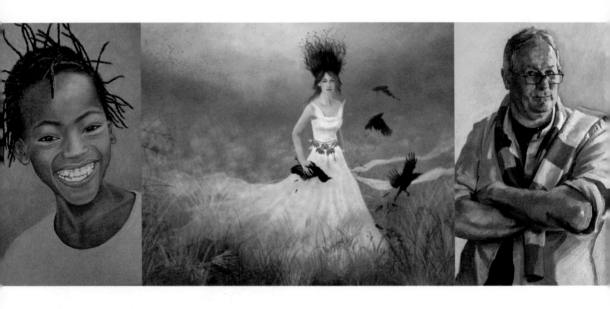

PROJECTS

The focus of painting portraits and figures is the representation of the human body. The projects included in this chapter will show you how to depict a face or a figure using a wide variety of media and techniques.

UNDERWATER
BY EVVIE KYROZI
MEDIUM: OIL ON CANVAS

step 1

I start by making a rough sketch on canvas. It looks pretty ugly right now but it doesn't matter, it only serves as a guide and the finished painting will look nothing like it. The point is not to make a beautiful, highly detailed drawing but to have a guide for your painting.

step 2

The base colours are applied using thin layers of paint. I want her hair to blend in with the background so I use tones of ultramarine blue for both of them and I also make sure parts of the background overlap into the fish.

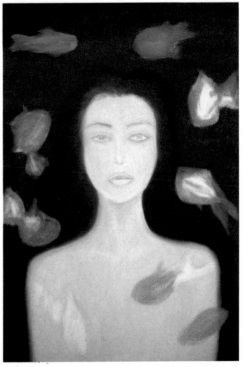

step 3

Now that the basic points are in, I keep on working on the whole composition using thin layers of paint and introduce her facial features, starting from the darker parts.

step 4

At this stage, I have just painted in the face, although it is still far from finished. The lips are painted in the same colour as the goldfish and the first tendrils of hair falling in front of her body are added.

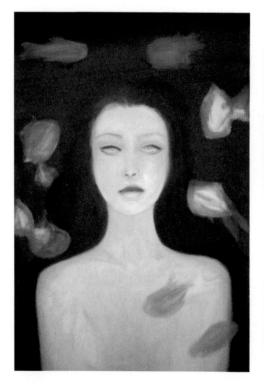

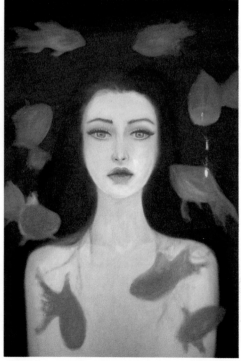

step 5

This is how she looks after I paint the
hair. I also add a little orange to her eyelids
by taking a soft dry brush, dabbing it into
a little bit of colour, wiping the excess
paint off and then rubbing it carefully on
to the canvas.

step 6

Using the same technique, I add more of the
same colour on her eyes and also to other
areas of her face such as the cheeks and
nose. With the face completed, I focus my
attention on the goldfish, shaping them and
adding highlights.

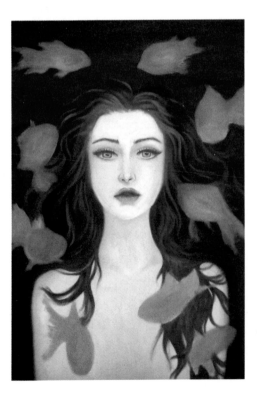

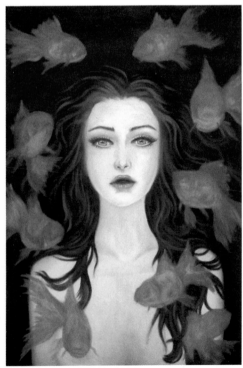

Step 7

I use a small brush for the details on the goldfish. I also paint the edges of their fins and tails the same colour as the hair. This makes them look playful and almost transparent but also ties in nicely with the rest of the painting.

Final Painting

I add more highlights for the fish and then bubbles, but not around her face since I feel this area already looks busy and colourful. Lastly, I give the hair more detail with the help of a very fine brush, and the painting is finished. Doesn't she look much more beautiful than the initial sketch?

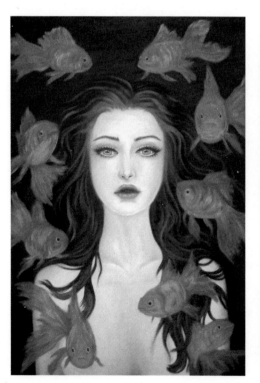

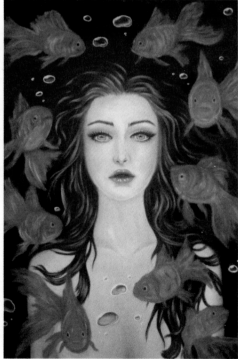

GIRL ON THE BEACH
BY ALEXANDRA FINKELCHTEIN
MEDIUM: OIL ON CANVAS

Step 1

I painted the background dark brown, prepared my flat brushes nos. 1–8, made a copy of the sketch from a book and transferred it to a size 45 x 60 cm (17¾ x 23⅔ in) canvas using chalk.

step 2

Using grey, white and blue paints I began
to paint the first shapes on the canvas,
keeping my brush flat side to the surface,
with minimum space between each shape.

step 3

Next, I painted the clouds and the
material beneath the girl, using a very
light grey. I used various brushes
according to the particular element
of the painting I was working on.

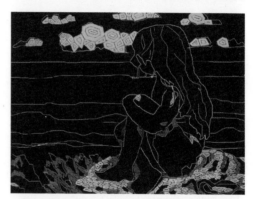

step 4

I painted the sky and the far part of the sea
with various shades of the same colour.

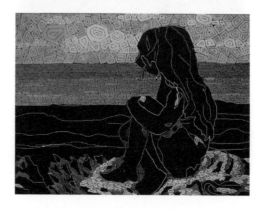

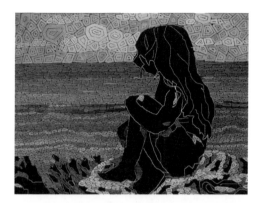

step 5

I painted the nearer part of the sea with various shades, between green and blue.

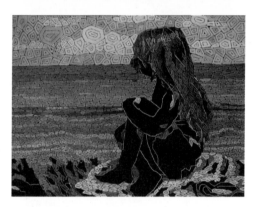

step 6

I used a variety of yellow and brown colours for the girl's hair.

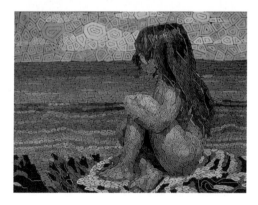

step 7

In this step, I took a skin-coloured paint and made different shades: one with white, another with yellow, a third with grey, a fourth with orange and a fifth with red. I used these to paint the girl's body.

Final Painting

Once the painting had dried, I removed the chalk outlines with water.

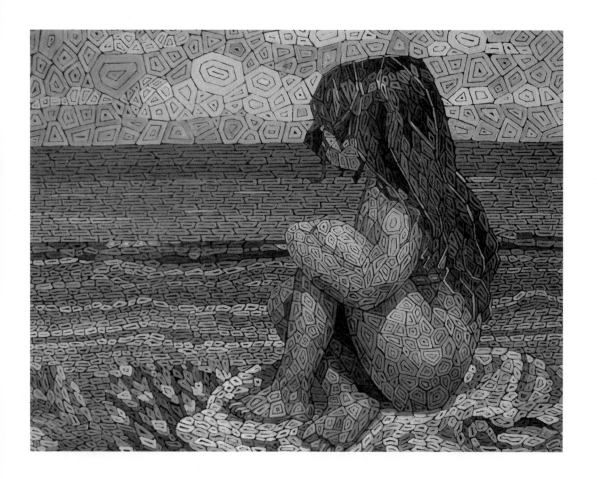

MAX DAFFNER BY ERIKA RICHERT
MEDIUM: ACRYLIC ON CANVAS

Max is a retired professional drummer who used to perform with 1950s bands The Jodymers and Bill Hailey and the Comets. I used a reference photo of him to paint this portrait.

Step 1

I like to begin each portrait by sketching directly on to the canvas with a pencil and then fill with paint. This sketch should take no more than 15 or 20 minutes. I often will flip the canvas and start again on the bottom then choose between the two sketches. It's kind of like a tennis serve, because you can take another shot. I always start portraits between the eyes and work outwards.

Step 2

At this point, I draw the composition with pencil and paint. I downloaded a few diagrams of drum sets to place in front of Max. I use different colours to build the composition, in the hope that I'll see the right colour combination and so not have to figure out which colours to use after this step.

Step 3

On the Merlin-style bathrobe, the moons and stars can be fussy, so at this stage I make gold spots on a colourful underlayer even though I intend the bathrobe to be dark in the final piece.

Final Painting

I make up the left hand holding the drumsticks because it isn't in the original photo. A hand can always be inserted, so to speak, but be careful to place it first, before connecting it to the shoulder. I draw star and moon shapes with pencil, daub dark paint around them and finally daub in lighter-coloured paint. On top of everything, I like to use an all-matte varnish or add a little gloss to a mostly matte varnish.

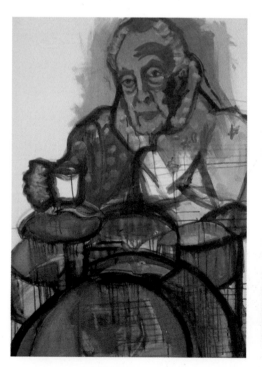

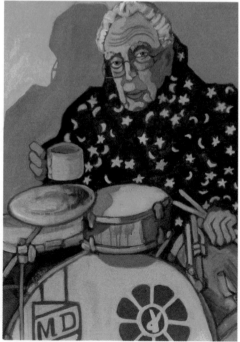

CROWDED BY MICHELLE KONDRICH

MIXED MEDIA/DIGITAL

step 1

Most of my illustration is mixed media. Here, you can see the finished drawing scanned into Photoshop. From here, I use Select>Color Range and I use the eyedropper to select the white area. Depending on how messy you want the final lines to look, you can adjust the Fuzziness appropriately.

step 2

On a new layer, underneath the lines, I use Kyle Webster's Photoshop brushes for almost all of my painting, so I retain a painterly look to the colour. I keep things fairly messy at this point.

step 3

On another layer, I start in on the figures. I like to paint the figures on a separate layer in case I need to move things around. It also makes editing colours or textures on the background simpler. I can also easily use adjustment layers or Image>Mode to make sure I have enough contrast between the figures and background.

step 4

Once I have the basic colours filled in for both the background and figures, I can start working on shadows and highlights. For the most part, I paint them directly on to the original paint layer but, in this case, the final highlights were on a separate layer so that I could experiment with layer modes and get the effect I wanted.

step 5

Now that most of the painting is finished, I start altering the line colour. I use Command-Click on the layer with the black lines to select all of them. I then use new layers and usually a very simple flat brush to paint the selected layers the colours that I want. My layer breakdown with lines is often Skin, Hair, Clothes, Background and Accessories or Miscellaneous (those are just my own names). You can isolate them however you like, of course. Once I have painted the lines, I hide the original black line layer.

step 6

Next I added highlights to represent the light from the window hitting the figures.

Step 7

For this particular illustration I decided it needed something more so I added the faint silhouettes in the windows and the bush on the right. Also, sometimes, when I finish an illustration, I like to create a layer of flat colour and then play with the layer modes to see if there is an effect I like. In this case, I preferred a layer that added more warmth to the colours.

Final Painting

Finally, I used a spatter brush in Photoshop to add the snowflakes. I also made sure to avoid making them white so that they could blend in with the image better.

PALISANDER
BY AMANDA BATES
MEDIUM: INK

step 1

This image was based on a sketch made at a concert of Palisander, a recorder quartet. I don't recommend Conté as a concert-sketching medium (here used on black khadi paper) – it was surprisingly noisy – and I soon reverted to fountain pen on cartridge paper (see the image below).

Other inks can be used for this process: fountain pen inks are great and there is a huge range of colours out there, but they are not lightfast. Acrylic inks are lightfast but do not handle in quite the same way; I have found that the transparent colours will work, but that some colours, such as Phthalo Blue, will need diluting before application or they will dominate the image.

Step 2

For the actual painting, I used generic inkjet inks (you can buy these in bottles to refill your printer cartridges; the colours – cyan, magenta, yellow and black – are fabulous, but they are not lightfast) on Hahnemuhle bamboo multimedia paper. I started by blocking out the light areas in masking fluid using a wedge-shaped silicon colour shaper. The masking fluid is easy to remove from the tool and I like the loose, sketchy effect I get with it.

step 3

When the masking fluid was dry, I used a big flat brush (1 inch) to wet the paper with clean water. I dripped and brushed ink on to the paper, letting it run, but always cleaning the brush between colours.

Final Painting

I then let the ink dry thoroughly before peeling and rubbing the masking fluid off. The final image has detail added in black ink and a few corrections in white acrylic ink.

WAR BY DEMI ZWERVER

PAINTING APPLICATION: PAINT TOOL SAI

Step 1

I sketched out my drawing and added colours underneath. In this drawing, I started painting before I had finished colouring because I was unhappy with the sketch.

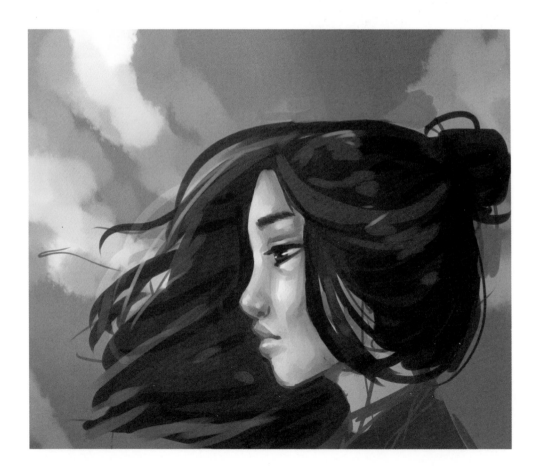

step 2

I detailed the hair and smoothed out her face, trying to make her look younger. I also used the Transform tool to fix some mistakes.

step 3

In this step, I once again used the Transform tool to fix mistakes in her face. I also edited the colours to get the feeling I wanted, and added the aggressive arrows as a contrast to her calm face.

Final Painting

Before finishing the piece, I made some more edits, and added light and shadows to get the feeling I was going for (Multiply layers are your best friend here). I blurred parts of the piece to make the arrows seem even faster and out of focus.

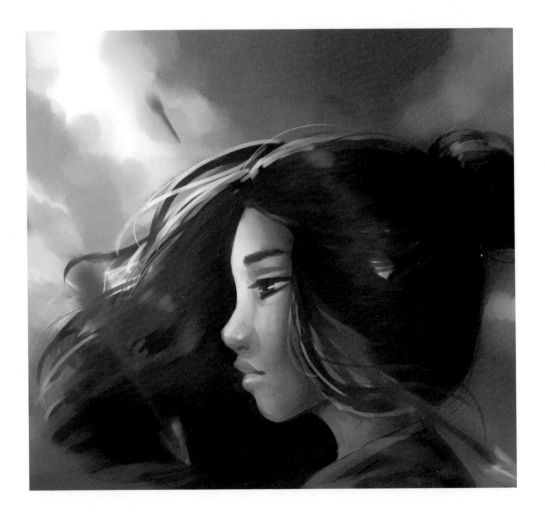

SILVIA BY OLGA DABROWSKA
MEDIUM: OIL ON PAPER

I like simple compositions and this one is portrait of a lady surrounded by natural elements: flowers, butterflies and birds. I decided on a warm colour palette and chose paper as my surface, unusual for oils but properly gessoed it allows for smooth work and a lot of details.

Step 1

The colours I used for this composition were Yellow Ochre, Naples Yellow Light, Crimson, Zinc White, Cassel Earth, Burnt Sienna, Burnt Umber, Ultramarine Blue and Cadmium Green Light. I also used the medium Liquin Original which speeds up drying time and allows thin glazes to be applied to create depth without weakening the paint film and colour.

Quick Tip: If you are painting on paper, remember to tape it down on to a sturdy surface to prevent warping, or you can mount it on hardboard.

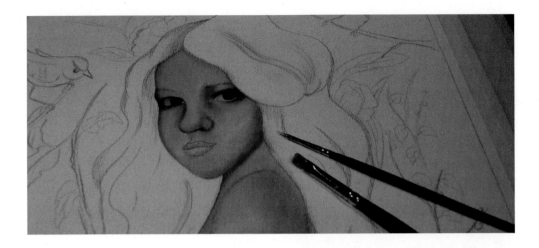

step 2

With my sketch transferred on to a 30 x 40 cm (11¾ x 15¾ in) paper suitable for oils, I started with the skin. For skin colour, I usually mix Crimson, Zinc White, Yellow Ochre and Naples Yellow Light; shadows are Burnt Umber and Crimson. Depending on your overall colour scheme, add some green or blue to shadows.

step 3

The skin is painted by laying down colour and blending it using an old brush with frayed hairs, simply dabbing the paint until it is blended. The background is done using a dry brush technique: scrubbing little bits of pure paint into the paper structure.

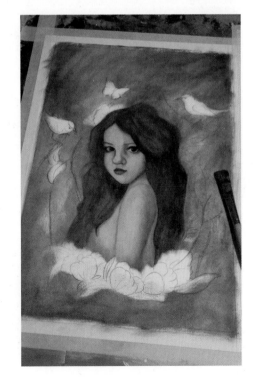

Step 4

In this step, I added a glaze between layers to add depth and unify the look of the painting. I used a large synthetic flat brush to glaze the painting after it was completely dry. I usually glaze with a transparent colour such as Burnt Umber thinned with Liquin.

Step 5

To create natural-looking twigs, hold the brush as shown here and use short, flicking moves, twisting the brush a little. Load the brush generously with paint mixed with a small amount of Liquin to help it flow. Don't worry about paint build-up in some areas, as this will create a realistic look.

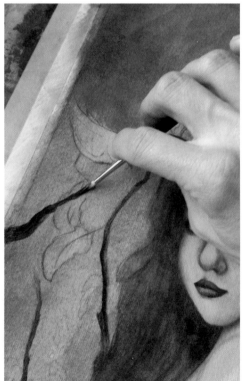

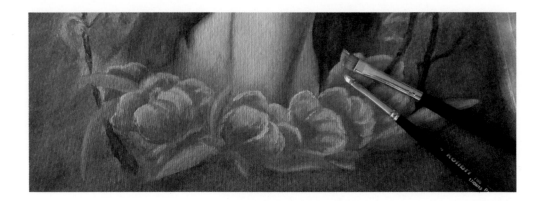

Step 6

I used the same technique to paint petals as I did for painting skin. Remember to shade them properly. Lay down the main colour and blend it with an old brush, dabbing into the paint until it blends well. While still wet, add highlights and shadows, blending them accordingly.

Final Painting

After it was dry – and as usual after a day or two – I looked at the painting with fresh eyes and added final details like darker areas on the hair and light on the petals and leaves. This completed the work.

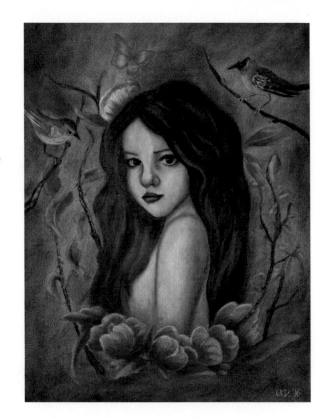

TATTOO BY EVVIE KYROZI

MEDIUM: ACRYLIC ON CANVAS

Step 1

I start with a sketch on 45 x 60 cm (17¾ x 23⅔ in) canvas. I want this piece to look more like an illustration and less like a realistic painting, so I choose to work with acrylics and use them differently to how I use oils.

Step 2

I begin blocking in the background using thin diluted layers of paint. It looks very messy, but I don't want it to be a uniform colour anyway. Besides, that is what's fun about painting: you start with a messy underpainting and work up to a refined artwork.

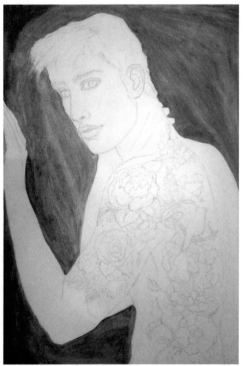

Step 3

I add another layer of diluted acrylic paint to the background and then use the same colour for the outline of the tattoo. Afterwards, I block in the face and body. Acrylic dries quickly, so I am able to work on the first layer of shading almost immediately.

Step 4

I am now ready to paint the tattoo, starting with the lighter colours and introducing the darker ones later on. Because my aim is to create a flat, illustration-like artwork, his tattoo doesn't wrap around his body like it would in a realistic painting.

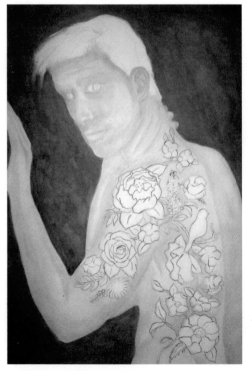
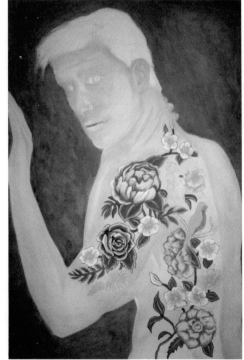

Step 5

In this step, I do more work on the tattoo and I also start colouring his facial features. I am now ready to work on the background. Using a template with different-size circles and a diluted mix of Titanium White and a little Cerulean Blue, I paint circles to give the impression of a bokeh (out of focus) effect.

Step 6

I add some dark blue in between the circles in order to give the picture depth as well as a watercolour feel. I also use the same colour for the second layer of shading on his body. I finish up the tattoo by reinstating the outline and making minor corrections to some of the flowers.

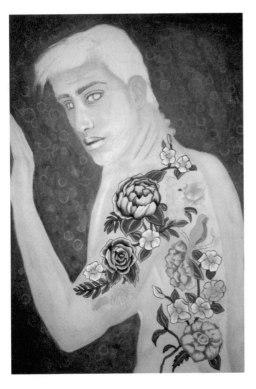

Step 7

I add another layer of shading to the body and then paint the hair using the same Ultramarine Blue. I give his facial features more definition and shape, with the help of shadows and highlights.

Final Painting

I outline parts of the body so it will look like an inked illustration. I then give the hair a little more shape and volume using confident brushstrokes. The finishing touch is my signature in the form of a tattoo and my painting is ready!

SHINE BRIGHT BY BARBARA PICKERING
MEDIUM: OIL ON CANVAS

Step 1

The dark or shadowed areas were scrubbed in with a thin layer of pure oil paint with a touch of odourless thinners to ensure that the paint grabbed the canvas. Lighter areas were added, blending the edges using a dry soft brush.

Step 2

I added details which would make it easier to shape the face later on, allowing a day or two of drying between steps. Each layer added was thicker than the previous. The rule is 'fat over lean', and is crucial to prevent cracking.

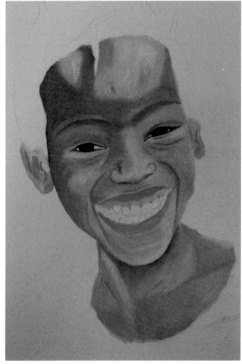

Step 3

In this stage, I continued to define the features. Here, the 'fat over lean' concept was used, where more linseed oil is used as a medium, making the oil 'fatter'. I used dots of white with a touch of Aquamarine Blue to spark the eyes to life.

Step 4

I blended the hard edges using a dry soft brush as the light and dark areas became more defined. The hairline was scrubbed in using Pure Black paint without any medium, which makes the first layer lean.

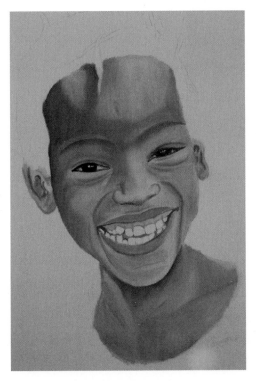

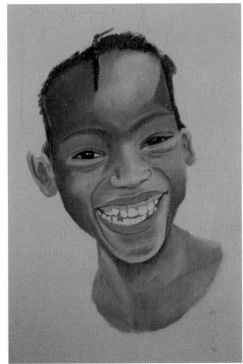

Step 5

Detailing the hair involved using the end of a round stiff brush to push the paint into the canvas. I added linseed oil to the paint, making it 'fatter'. Highlights were added to the hair so it doesn't look flat.

Step 6

I added more layers while continuing to blend dark and light areas. I also added detail to the mouth area, eye folds and eyebrows. This is where the face starts to come to life. It is an understanding of shadows and light.

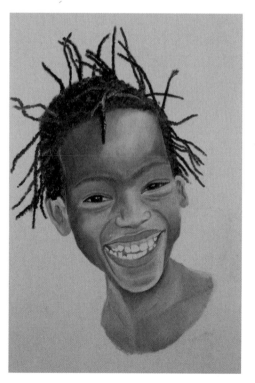

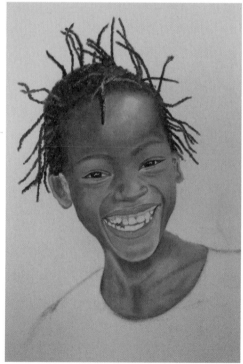

Step 7

I painted in the background using a flat brush with a mix of three or four colours, and painted the shirt. I added more fine facial detail and highlights, always keeping in mind where the light source is coming from.

Final Painting

I added detail to the ears and neck, and highlights were also added. After the painting dried, it was glazed using Liquin with a tiny bit of raw Umber paint. Glazing allows the undertones to shine through and creates a more lifelike painting.

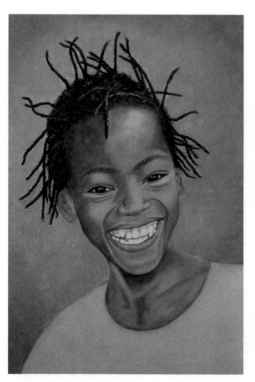

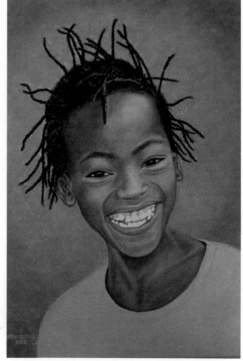

LURKING PANDA BY DAVID COUSENS

PAINTING APPLICATION: DIGITAL

step 1

I always start by trying to get the essence of
an image down. I use a loose sketch because
I know I'm going to be painting most of the
detail in. I use a soft green as a base colour.

step 2

I start painting underneath my line work so that I can keep making the brushstrokes expressive
without worrying about losing detail and the layout. I use Photoshop's Mixer brushes to pick up
the paint already on the canvas.

Step 3

I start to paint in different elements of the jungle to add some depth to the image. I also decided to go for a closer crop to make the image feel more cinematic and add some drama.

Final Painting

I finish by refining the paintwork and adding some dark forground elements as well as a few subtle blurs to push the feeling of depth. As a finishing touch, I add some gradients on an Overlay layer to enhance the colours.

FACE BY DEBORAH WAINWRIGHT

MIXED MEDIA

Step 1

I applied at least two colours of acrylic
paint to the substrate; in this case, I
used a canvas board. Using a brayer,
I moved the paint around roughly,
until it covered my page.

Step 2

I tore up pieces of printed paper, ensuring
they all had uneven edges, and stuck them
randomly to the page using a medium Matte
Medium. I then covered the page with the
same colour acrylics as before, wiping it back
to reveal areas of the papers.

step 3

Once it was dry, I used a sanding block to smooth over the roughest areas and cleaned back to the paper, leaving a balanced-looking page. I sprayed this layer using highly pigmented Die spray. I let the paint sit for a few seconds before holding it up to allow the paint to run.

step 4

Once it was completely dry, I added crackle glaze randomly and left it to set. It needs to dry off but not be too dry as otherwise you will not get any crackle. When it was ready, I used an acrylic spray which dries permanently and gives a fabulous texture.

step 5

I sketched out my basic features
with a white water-soluble pencil.

step 6

Using watercolour paint, I
started to add in shadows.

Step 7

Switching to soluble oil pastels,
I continued to add in lights and tones.

Step 8

I added more layers, building up the
shadows and lights, adding colour to
the eyes and mouth.

Step 9

I refined the face, adding more
definition and colour.

Final Painting

I switched again to soft pastels for the hair
and clothes. I finished off with line work on
the lady's blue top and elsewhere using a
white pen.

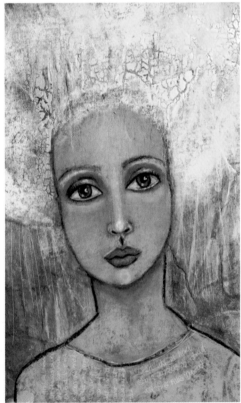

ASHES BY SIRIS HILL

PAINTING APPLICATION: PHOTOSHOP

step 1

To achieve realism, I work with references, either my own photos or from stock photos. I begin with a sketch/underpainting. I keep my palette de-saturated, selecting basic skin tones (reds and purples) as I don't want to think about colour at this stage. I'm very loose at the beginning: without focusing on perfect proportions, I make suggestive brush marks to find the placement of the body and to build the silhouette.

Quick Tip: Stay away from using a pure white and black as these rarely exist in the real world and can ruin the realism of a painting.

Step 2

With the underpainting complete, I turn my attention to the strongest light shapes and the darkest shadow areas. This helps the form begin to take shape. I create a lot of fast light marks on the top of the canvas to suggest the idea of an explosion with smoke, as if the head had burst. I balance the colour palette with warm shadows and cool lights, but colour is still not my main concern at this point.

Step 3

In this step and the next, I start organizing the space and working out the final composition for the piece. You will notice drastic changes as I cut off a large part of the background, bringing the viewer closer to the figure. This is to make the figure feel large on the canvas and create a claustrophobic feeling.

Step 4

For me, this is the best part of the painting.
At this point I relax, put on music and paint
freely. My focus is upon detailing each area.
At this point I am painting through my own
instincts. I am cross-referencing with my
reference photos to ensure my proportions
and lighting are accurate.

Smudge Tool

*Whilst painting, I'm constantly switching
to the smudge tool. This tool allows
me to even out my brushstrokes and
blend colours together. I also use this to
create lost edges, by blurring the edges
of the body into the background. The
figure's left arm is a hard edge against
the smoke and background. Down at
the stomach the edges become softer,
losing themselves to the background.
This is all done to guide your eyes
through the composition and create
landing spots at the focal points. You can
see examples of this in the final painting.*

Step 5

Lastly, I added in the fine details, such as the particles and smoke around the head; I also added dimension to the hair with stray strands. I created the particles in two layers: first an underlayer in a cool grey-blue, creating lines varying in length which create a motion blur effect; I used a brighter yellow-white in the second layer to give the appearance of some of the details catching the light. The hand needed more detail since it's so close to the focal point, so I added some bounce light to the nails and some extra veins on the back of the hand.

Quick Tip: Don't go crazy on details. Omit all but the essential elements and remember correct values are the most important thing.

Final
Painting

GC PORTRAIT BY STEPHEN ROSE

MEDIUM: OIL

step 1

The shapes were loosely drawn, using thinned paint. The background was painted first. Always consider the effect of light behind the figure. The colours I used in the painting were: Burnt Sienna, Raw Sienna, Burnt Umber, Yellow Ochre, Cobalt Blue, Viridian, Cadmium Red, Magenta, Zinc White and Titanium White.

step 2

A loose beginning allows for further change. The figure now leans against a wall, creating space and informality. The primary forms in the shirt and head were painted and the position of the head, shoulders and arms were established.

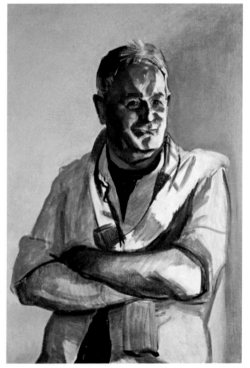

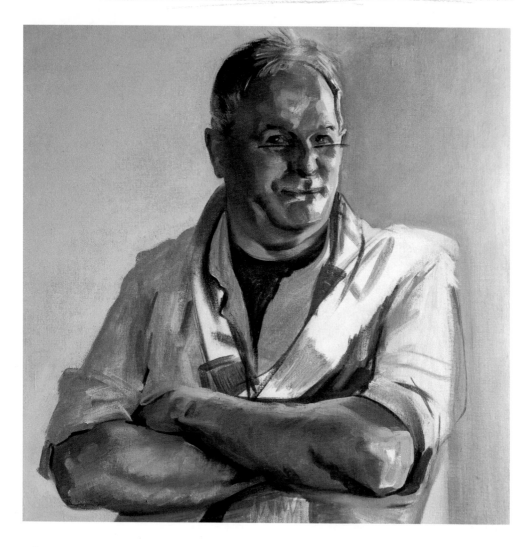

step 3

The forms of the arms and their relationship to each other were established, creating a dynamic confrontation with the viewer. The features and the shape of the head were developed. Warm and cool contrasts in the shirt were introduced.

step 4

The subtle forms of the face, eyes, nose and mouth were painted. The spectacles were positioned in relation to the ear and nose. Darker tones of blue were introduced into the shirt, developing form, tension and the pull of fabric.

step 5

I made further minor adjustments to the mouth and eyes which contribute to the character of the sitter. The scarf was painted, creating a colour accent that will relate to the existing colour harmony and not detract from the head.

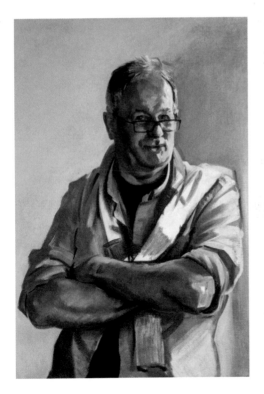

Final Painting

Before the painting is almost complete, take time to review the painting, only changing those elements that lessen the impact of the image. Simplify any confused or ambiguous areas. Strengthen contours to develop space, weight and tension.

SOUL SEEKER BY OLGA DABROWSKA

PAINTING APPLICATION: PHOTOSHOP

Fantasy themes enable the artist to tell many wild stories, immerse the viewer in worlds that exist in the artist's mind and allow for a lot of freedom regarding landscapes, creatures and overall feel of the image. While based on fictional stories invented by the artist or already existing, the work should still have strong roots in classical drawing and painting. No good fantasy image is created without planned composition and mood.

Step 1

I wanted to show a dark, beautiful lady hunting for lost souls in a misty field and a cloudy atmosphere. To plan out elements, start with big brushes, lay down distant mountains and foreground grass and mark the spot for the lady. Decide on a colour scheme and light source – in this case, diffuse light shining directly on our character.

step 2

A colour change using Levels and Color/Brightness gave a more dramatic look. I decided to go with a violet theme, so added spots of yellow. As a complementary colour to violet, yellow will immediately 'fill' the image. I added details such as grass and dead trees. I worked on clouds with soft brushes, circling moves and low opacity.

step 3

Pale skin tones were painted using muted peach and cold blue with spots of orange. I kept the hair wild to emphasize the lady's unreal appearance. Flowing cloth suggests wind that doesn't touch the hair: the lady creates the wind but does not submit to it.

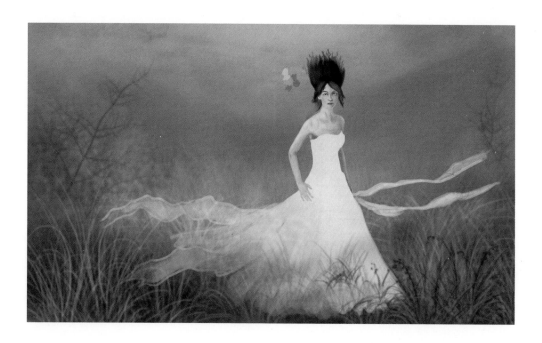

Step 4

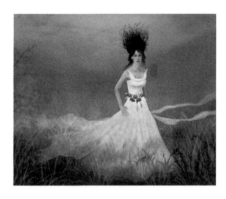

The dress is made of fine lace and glows mysteriously. I created a glow on a new low opacity layer above the dress, using soft brushes, in a light peach/yellowish colour in Normal mode. All details are painted with varied opacity using a standard hard round brush. I used Mirror image to see any mistakes with a fresh eye.

Step 5

I added more foliage to the background. Layer by layer, I blurred with Gaussian Blur in the most distant areas. The ravens here symbolize dead souls; look for references to paint them properly. Check your values by duplicating all layers on top of themselves and turning to Black and White layer; if the values are right, the image is right.

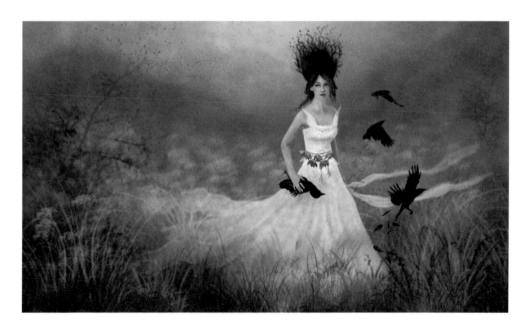

Final Painting

I merged all the layers and added finishing touches, including the bird's skeleton near the lady. I checked the values once again, fixing lights and shadows on the skin. Lastly, I gave the painting a final tweak of colour using Levels, Hue/Saturation and Brightness/Contrast.

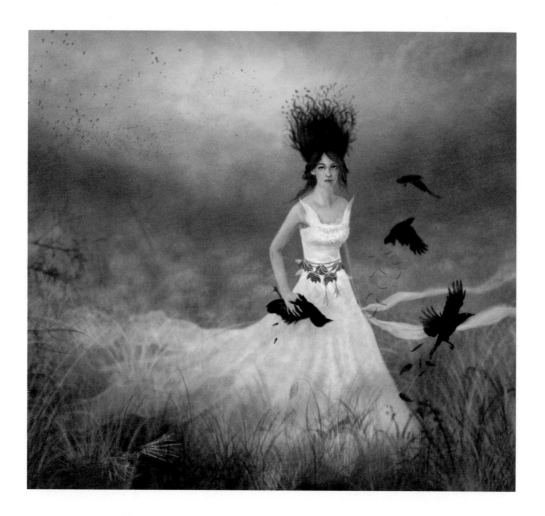

SELFIE BY EVVIE KYROZI
MEDIUM: OIL ON CANVAS

Step 1

I started by sketching my subject on the 50 x 60 cm (19⅔ x 23⅔ in) canvas. I drew the lower part of her left arm slightly bigger since it's the one she's holding the camera with. I then did the same for the upper part of her head, which looks bigger since it's tilted towards the viewer.

Step 2

I laid down the first washes of colour using water-soluble oils. This is my favourite stage of the painting process and I used several thin layers of paint. This is when I decided to make some minor changes to the composition, such as to replace the decorative patches on her top with a drawing.

Step 3

The background was blocked in using a mix of Titanium White and Cerulean Blue. I experimented with using a light purple shadow for her skin and then I did the underpainting for the drawing on her top. After I was happy with how those looked, I moved on to the hair.

Step 4

I do most of my colour mixing on the canvas and for this painting I wanted to use many different colours in her hair, ranging from orange to dark pink. A few stray hairs were added in order to give it a messy look, and then I introduced the first layers of colour to her accessories.

Step 5

After applying the base colours for her hairgrips and glasses, I turned my attention to her face. I'd already added more layers of colour to her skin and so I worked on the overall shading, using thin layers of purple and also gave more detail to her eyes, lips and the drawing on her top.

Step 6

I finished painting the eyes by adding eyelashes and highlights. After making corrections to her face, I experimented with painting her mesh top using a diluted Titanium White that will serve as a guide to make sure I like it and to give me direction for later.

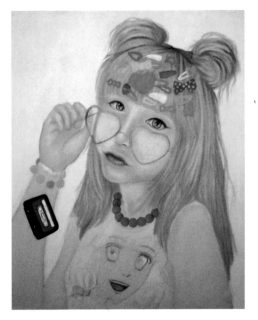

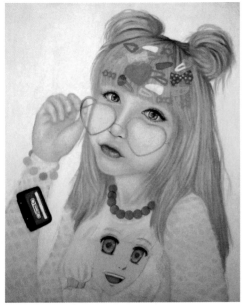

Step 7

So... have you noticed the mistake yet ? Somehow, she ended up with six fingers! I made sure to correct my mistake and then added another layer of shading to her skin as well as continuing to work on her top by outlining the drawing and colouring in the eyes.

Finished Painting

This is the final step where I bring everything together. The illustration on her top was painted using the same colours as some of the hairgrips so every colour appears twice, giving balance to the composition. I then painted the mesh top by using a thick layer of Titanium White and also darkened some parts of the background to give more depth. I used the glazing technique of a thin, transparent layer of colour over a dry one for her glasses and, after adding details here and there, my painting was finished.

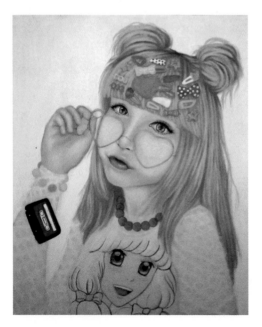

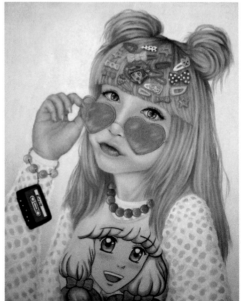

COLOURFUL KOI FISH BY SANDRA TRUBIN
MEDIUM: ACRYLIC

step 1

I made a detailed sketch of a Koi fish in
a lily pond with a lot of pebbles on Bristol
paper. I want the painting to be almost
over-the-top colourful and very detailed;
having the sketch helped me position
all of the elements.

step 2

I began filling the background with
the first layer of paint using craft-type
acrylic paint, creating green lily pads and
very colourful pebbles.

step 3

Here, I added the first layer of paint to the fish, using red and orange as the base for the scales and light blue for the fins and tail.

step 4

I began outlining each of the pebbles and lily pads, then adding patterns and details using a fine brush.

Step 5

I finished the details on the pebbles and began working on the fins of the fish, still using the fine brush and making long, thin lines.

Final Painting

I added the final touches, dropping shadows under the Koi fish and the lily pads, and adding ripples to the water to give the painting more dimension.

TEA TIME BY DEMI ZWERVER

PAINTING APPLICATION: PAINT TOOL SAI

Step 1

I sketched out the scene I had in mind with a dark brown brush. I blocked in some colours underneath, and added light and shadows to get a general idea of where I wanted the painting to go.

Step 2

I merged all the layers, saved a copy, and painted over my coloured sketch layer. I tried to create some depth in the background to get that 'forest' atmosphere.

step 3

Here, I edited the colours a little, making them brighter and more saturated. I made the background darker, and added stronger light. I also refined the painting.

step 4

In this stage, I carried out some more colour edits and did more refining.

Final Painting

I added some final details:
more foreground branches
and leaves as well as more
details in the background.

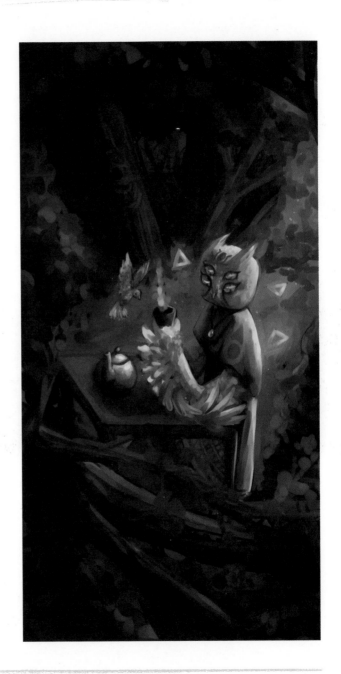

The Great Outdoors

PROJECTS

This chapter will give you ideas on how to capture the essence of the modern landscape, including both natural landscapes and cityscapes. The projects included will show you how to paint different elements such as trees, as well as ways to depict the sky and the sea.

BETTER DAYS BY DAVID COUSENS
PAINTING APPLICATION: PHOTOSHOP

Step 1

To save a lot of time on environment speed paintings, you can use actual photos to get you started. Here, I've overlaid four stock photos with differing levels of opacity.

Step 2

I wanted a post-apocalyptic feel, so I created a new layer on top and started painting out all of the evidence of things like cars that would make it feel civilized. I also painted in some dark foreground elements.

Step 3

I painted a nomad into the foreground to tell a story, and used some custom brushes to make everything look a bit more run-down and abandoned. Lots of debris is now visible to add to the chaotic feel.

Final Painting

A final storytelling element was added of a giant plume of smoke, to show that something is still going on amidst the carnage, leaving us to wonder what the character will do in response to this event.

ROCKPOOLS BY MATTHEW EVANS

MEDIUM: ACRYLIC AND TEXTURE PASTE ON CANVAS

step 1

I covered the canvas with a loose acrylic underpainting and applied thick texture paste with a palette knife in sweeping strokes. In the foreground, I used a mica gel to give a rock-type feel.

step 2

I used acrylic to pick out the rich colours of the rocks and the reflection of the water in the foreground. This image, with its simple, bold shapes, enhances the texture of the rocks, and the deep blue on the right brings forward the rock reflected in the water.

Step 3

The rocks are now picked out with deep contrasting colours and a pearlescent gel is used to give a silver light which, in places, will shine through the final layer of paint and add to the dancing effect of the light. The figures add life to the scene, and the rock faces, which go in all directions, add movement.

Final Painting

I was first attracted to this scene by the wonderful textures and colours in the rocks which changed in various different lights.

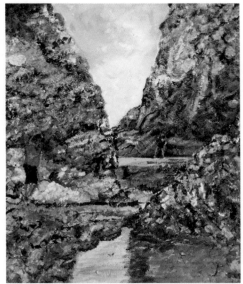

ROUTINE BY SHARMAINE KWAN
MEDIUM: WATERCOLOUR WITH PENCIL AND CHARCOAL

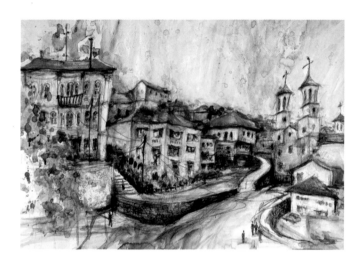

I used water-soluble graphite pencils and charcoal to draw the loose repetitive lines. The watercolour was applied freely with dynamic brushstrokes and paint was splattered to convey the trees.

MEMORY LANE BY SHARMAINE KWAN
MEDIUM: ACRYLIC AND EMULSION

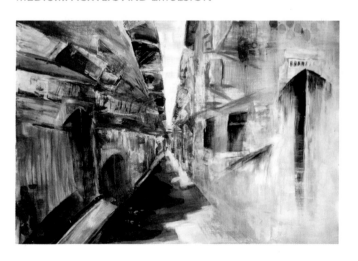

This painting was made using acrylic paint and white emulsion. I used tools such as rough bristle brushes and spatulas to apply the paint directly without diluting it with water and also scratched marks on to the surface.

GREENHEAD PARK BY MATTHEW EVANS

MEDIUM: ACRYLIC ON CANVAS

Step 1

I made a very quick sketch in pencil just to establish the main areas and composition.

Step 2

I used loose acrylic wash to block in the main areas of sky and grass and to build up a bright underpainting.

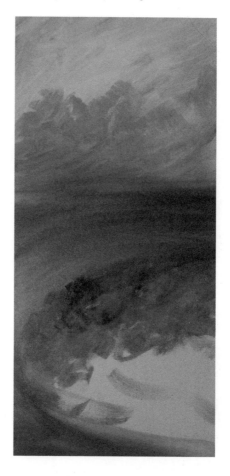

Step 3

Here, I used a broad brush to enhance the foreground which will eventually form the main point of interest.

Step 4

In this stage, a stiff-bristled square brush was used in a 'sgrafitto' effect to add texture and movement to trees, and to manipulate the wet acrylic into various interesting patterns.

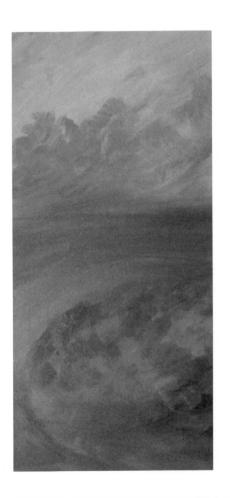

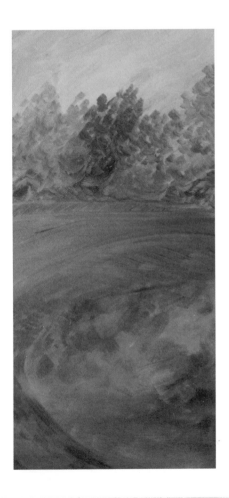

step 5

Heavier and bolder acrylic builds up the foliage and I used a fan brush to feather the trees and to break up the more solid areas. I then built the flower bed up with a dark background and bright blocks of impasto paint often used undiluted straight from the tube.

Quick Tip: Acrylics are affordable, making them ideal for covering large areas. Because these paints are fast-drying, they can be very forgiving, allowing you to cover up your mistakes with more paint.

Final Painting

Finally, figures added life to this pleasing park scene.

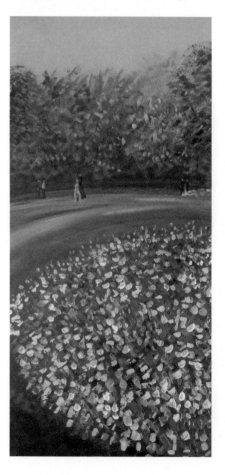

PROWLING JAGUAR
BY DAVID COUSENS
PAINTING APPLICATION: PHOTOSHOP

step 1

I find jungles really fun to paint because you can make them fit whatever mood you need. I decided on using a huge main tree with a twisted curl that reflects the jaguar's prowling movements.

step 2

Here, I've added a lot of bushes largely by suggesting detail with a number of custom brushes. I detailed the larger trees that recede into the background with a soft paintbrush and used less saturated colours to suggest distance.

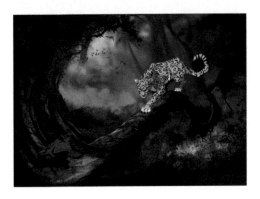

step 3

For the shading, I not only shaded the animals, but added shadows cast by leaves that we can't see in the forest's canopy. Adding hints of things that we can't see in the image makes the scene feel even bigger.

Final Painting

To make the environment more sinister, I painted in some spikey branches towards the focal points and applied a Gaussian Blur. I added some colour gradients to give the jaguar a hint of red, to give a feeling of danger.

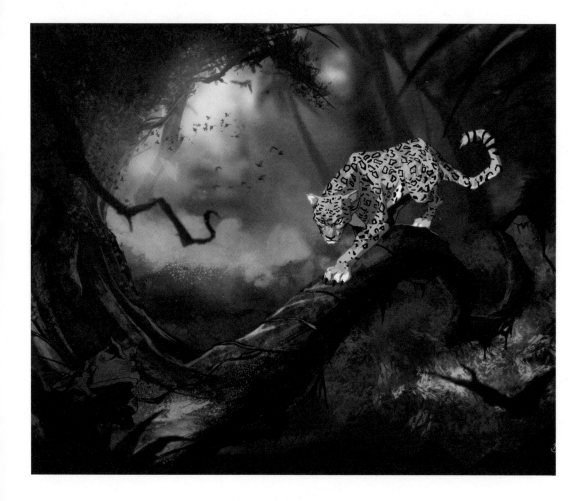

BLUEBELLS
BY MATTHEW EVANS
MEDIUM: ACRYLIC ON CANVAS

Preparatory Pastel Sketch

I enjoy using pastel on black paper, and I created a colour study (right) to work out composition and colour balance for the painting to come. This also gave me a chance to study the scene and make an aide memoir.

Step 1

Starting with a quick sketch layout, I covered the surface with light acrylic to remove the white canvas. I then used a palette knife and red and white texture paste to add base textures. Areas were also added in a stippled effect with a brush. This should be left to dry overnight if possible and can be scraped into whilst wet to give various effects.

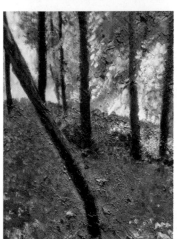

Step 2

I now introduced acrylic colour, with the red of the underpainting adding richness and the textured ground enhancing the impasto effect. Main areas of colour were established and the light is picked out between the trees.

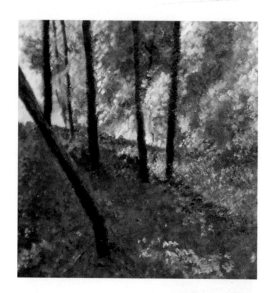

Step 3

This build-up of colour continued with more detail being added to the trees. I made the foreground stronger to encourage the bluebells to become the main colour interest. I also used thicker paint to enhance the textured feel.

Final Painting

I continued the stipple effect by making use of undiluted, heavy-bodied acrylic to enhance the colour and a little extra white texture paste to the right-hand side to pick out highlights. The darkness of the trees contrasts with the light falling on the foreground and gives pride of place to the bluebells.

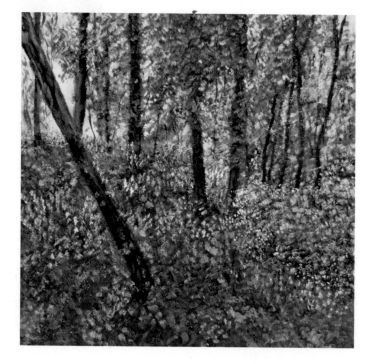

TIKI & MAMBO BY DAVID COUSENS

PAINTING APPLICATION: PHOTOSHOP

Step 1

When drawing scenes, I like to rough sketch a lot of the elements in advance to make sure the layout works and that I get a sense of the environment.

Step 2

With everything laid out and the line work drawn, I started to lay out the base colours and the basic background to set the feel of the location and give myself an idea of how the final image will look.

Step 3

I love getting to the stage where I can start adding the smaller details, like the fur on the hamsters, the shadows of everything and the glow of the fireflies.

Final Painting

Here is where the image came together, including adding lots of textures, some extra layers of fauna, the typography of the signs, the starry sky and some swirling clouds inspired by the excellent artist Bill Tiller.

SUNSET SEASCAPE BY MATTHEW EVANS
MEDIUM: PASTEL

step 1

Here, I used a small sheet of black abrasive paper as a ground and built the main colour areas up with broad strokes using the sides of blue, yellow and white pastels. The dark ground enhanced the areas where intensity of colour was paramount, and pushed the colour forward. Rapid strokes allowed spontaneous mark-making, giving life and movement to the piece.

Step 2

Blue and orange was used to build up the intense colour of the sunset sky and light yellows and white were used horizontally to give a suggestion of the horizon line and the water. Several layers of overlaid pastel begin to blend themselves, but care is required if blending with fingers on abrasive paper; good alternatives include paper, rubber blending tools or rolled-up tissue paper. As blending takes place, the tooth of the paper is filled and the black background is less exposed, although the colours maintain their vibrancy.

Final Painting

The light on the water was a very important aspect of this artwork and the abrasive paper really allowed the white and yellow to be added with no loss of intensity. The darkness of the headland provided contrast to enhance the brightness of the water further. In the foreground, I left a little of the paper to show through to give the idea of ripples on the water.

Quick Tip: Pastel is a very useful medium for rapid note-taking, either on site or in the studio. The pastel can be sprayed with a fixative, although the tooth of the paper will hold most of the pastel and any excess will drop off with a gentle tap.

HAY BALES
BY SEBASTIAN
MEDIUM: GOUACHE ON PAPER

Step 1

I began with a rough sketch of the landscape, using a light, thinned-out colour, and outlined the hay bales, trees and hills. I painted with a small bright brush on 290 gsm (136 lb) paper.

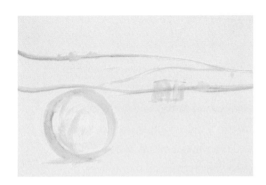

Step 2

Starting with the hills in the background, I applied thick strokes of paint. I used a darker viridian green for the distant trees and forest, bright yellows for the hills and brighter greens for the fields.

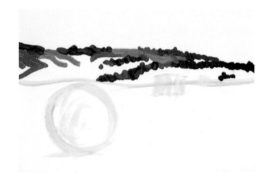

Step 3

Here, I continued with the lighter yellow for the field in front.

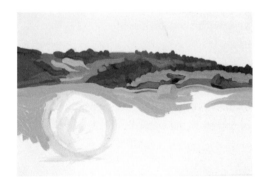

Step 4

I painted the hay bale with a light umber and started to give the painting flow and movement by using thick strokes of broken colour.

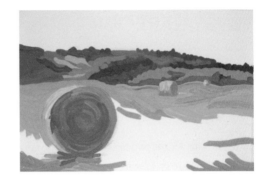

Step 5

I now added more highlights and shadows to the hay bales and outlined the clouds.

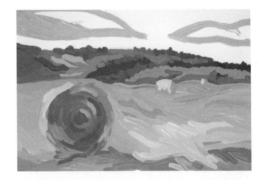

Final Painting

I continued filling in the sky and clouds, and finished off by adding more detailed strokes to the hay bales.

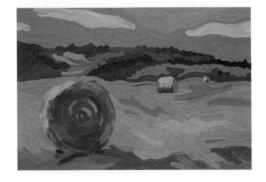

TENBY HARBOUR BY MATTHEW EVANS
MEDIUM: ACRYLIC ON CANVAS

Step 1

I started with a light pencil sketch to pick out the main areas. I then used acrylic to block in the main boats. A palette knife was used to apply white texture paste to add interest and movement to the water; this also helps to establish tonal values.

Step 2

Detail was added to the hotels and buildings in the background, and the orange and blue of the sky was reflected in the textured water using acrylics. The boats became more defined with highlights picked out on the windows.

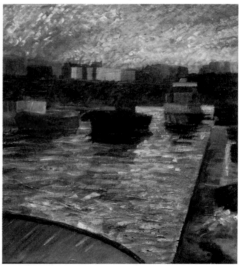

step 3

Gradually, more detail is built up on the shapes of the boats and the windows in the buildings. The dark of the lamppost contrasts well with the bright sky, and reflections are picked out in the water on the quayside, which adds interest.

Final Painting

The finished article contains all the elements that I worked towards: stunning colours in the sky that are reflected in the gently rippling water, the contrast between the dark and light areas and the extra interest provided by the boats and houses.

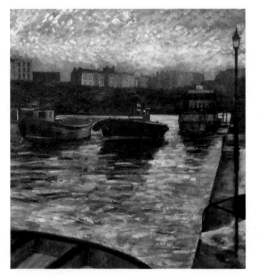

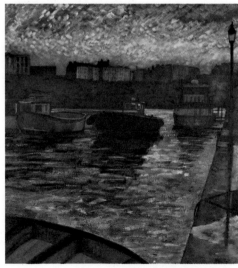

HOUSE
BY SEBASTIAN
MEDIUM: GOUACHE

Step 1

I started off with a pencil sketch, outlining the houses, trees and hedges.

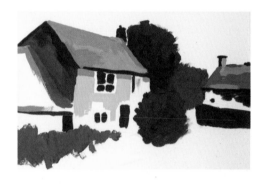

Step 2

I began painting with the darkest values of the scene. I roughly painted in the trees, hedges and shadows.

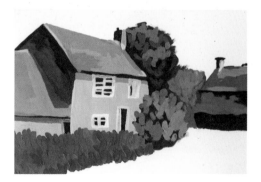

Step 3

I layered bright leaves on to the trees and hedges, and also filled in the houses and roofs, paying close attention to the light and dark values.

Step 4

In this step, I added a light yellow and light blue for the grass, which contrasted well with the houses.

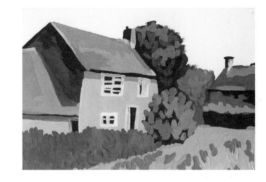

Final Painting

Lastly, I added in the clouds, sky and hill in the background. I took stock of the painting, and made some small corrections and added in a few details, taking care not to overcrowd and overwork the painting.

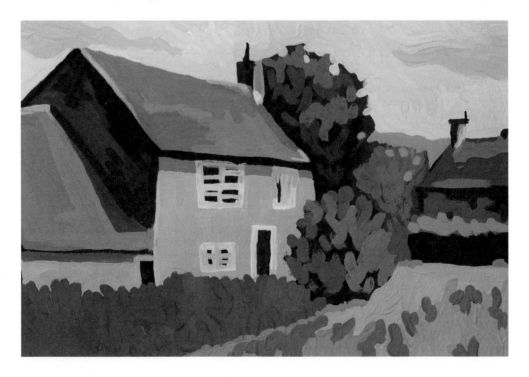

BREATHING SPACE BY DAVID COUSENS

PAINTING APPLICATION: PHOTOSHOP

Space 1

To draw the viewers' eyes to a faraway destination, the settlement is placed against mountains that have been rendered with very little detail; just enough to suggest they're mountains, but not so that it distracts attention.

Space 2

When images are set in a busy or crowded scene, it's helpful to have an area of the image that lets the viewers relax. Too much visual information detracts from images, so things like large boulders can offer visual harmony.

Space 3

Breathing space doesn't have to always be provided by the sky; it can be any large area of empty space. Here, the camera is pulled up high and the breathing space is the sandy floor.

Space 4

Large areas of sky used as breathing space offer either a sense of freedom or isolation, depending on the setting. Here, the desert sky feels oppressive, and the emptiness helps us focus on the narrative element of the skull.

Space 5

Breathing space can also be the main element of an image. Here, the vastness of the sea is depicted by giving it such dominance over the image. Even though it takes over the majority of the space, it continues beyond the borders.

Space 6

Sometimes breathing space can be supplied by a simple element like a blank wall that also doubles as something that points the viewer in the direction of the main point of interest.

Abstract style

PROJECTS

Abstract art is focused on form, colour and expression instead of representing reality. This chapter will show how various styles and techniques, such as dripping paint can be applied, combining figurative with abstract elements, and transforming subjects into geometric forms.

HOOPOE IN THE FIELD OF ANEMONES
BY ALEXANDRA FINKELCHTEIN
MEDIUM: ACRYLIC

step 1

If possible, use acrylic paint from the Americana series, or any other acrylic paint with a 'chalky' opaque quality. The original size of the image is 40 x 50 cm.

step 2

Next, I painted the sky and some flower elements in different shades of light blue, as can be seen in the final image.

Step 3

Using a variety of violet coloured paint,
I filled in part of the far background and
some of the flowers.

Step 4

I painted the nearer section of the background
using light grey and blue paint, as well as some
parts of the field of anemones.

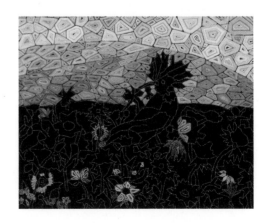

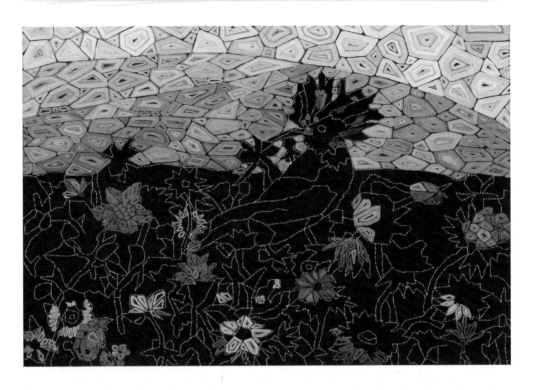

step 5

In this step, I chose rose and orange paints, as well as a mix of the two. These colours contrast very well with the blue and violet of the background sky.

step 6

I next added different shades of yellow to the flowers and to the hoopoe's crest; the crest, in particular, is starting to stand out well against the blue-violet sky.

Step 7

I used various shades of turquoise in some
of the foliage and flower stems; I like how
these lines of bright colour shine out of the
final painting.

Final Painting

To achieve the final result, I continued to fill in the empty areas of the canvas, ensuring
that the anemones and the hoopoe's crest stood out from the backgrounds.

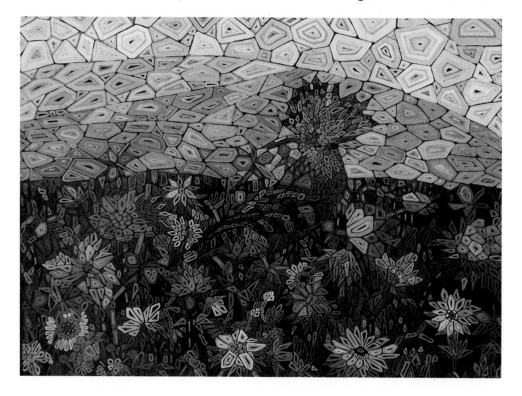

COLOURS OF DAWN BY SANDRA TRUBIN

PAINTING APPLICATION: ARTRAGE

step 1

This painting was created in the ArtRage program, which has a very similar feeling to traditional work because of the tools that it has. I like to begin with two or three main colours and work with them and their blends.

step 2

After throwing down a few quick brushstrokes, I begin to form the shapes that I find visually appealing for my composition. It is a playful process of exploration to find the right direction for the piece.

Quick Tip: ArtRage software is available across a range of platforms (mobile and desktop), inexpensive (or free as a trial) and a great bridge between traditional and digital media.

Step 3

When I'm happy with the composition, it's time to focus on the shapes, smooth the edges and let the colours blend together for a more polished look.

Final Painting

There is a stencil tool in ArtRage that can be customized and used to create different patterns, an element that I like to include in most of my work. I used this to add a few more fun details and the painting is complete.

GLIMPSE OF THE GARDEN
BY GIOTA PARASKEVA
MEDIUM: ACRYLIC ON CANVAS

step 1

First, I did a rough sketch on my canvas as a guide for my composition.

step 2

I then laid the canvas flat and spread a rich layer of acrylic gloss medium over it with a flat brush. I used the gloss medium to increase the flow of the paint and create a stable base paint film.

Quick Tip: Acrylic gloss medium is translucent when wet and becomes transparent when it dries.

step 3

I poured globs of acrylic paint on to the canvas while the acrylic gloss medium was wet.

step 4

I spread the paint globs out with a flat brush and a palette knife and let it dry completely before moving on to the next step.

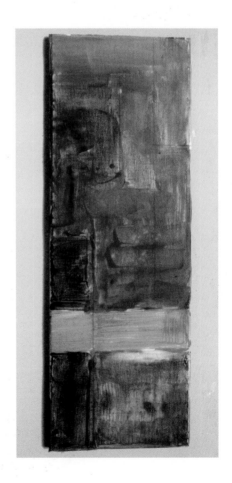

step 5

I started adding colour to the bottom area in a more detailed way.

step 6

Next, I worked on the green area using both a flat brush and a palette knife. In some areas, I used gloss medium to add body to the paint.

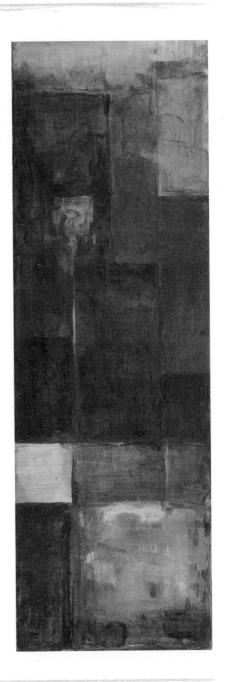

Step 7

I continued to add more layers of colour
all over the painting.

Final Painting

I added some more colour in thin layers and
finally some heavy strokes until I finalized the
composition and was happy with the result.

SADNESS BY LUKÁŠ KUBLA

PAINTING APPLICATION: PHOTOSHOP

step 1

I started with a sketch that set out
my first vision of the final picture.

step 2

I used brushes and settings that reminded
me of real brushes on real canvas. I slowly
added in pieces of the face.

step 3

In this step, I started painting in the eyes and mouth. I also used my favourite paint-roller effect. This effect is essential for me in my abstract works.

step 4

I added more and more details of the face. As you can see, the picture is slowly reaching its final form.

Step 5

By this stage, the final face form is complete. I needed to make a few slight adjustments and also to edit some parts that I wasn't happy with.

Final Painting

In the last step I hid the layer which contained the sketch. I finished the picture with lines that I wanted in the final composition. At the very end, it just needed a little touch of the Unsharp Mask filter, and 'Sadness' was finished.

CAPTURED
BY SHARMAINE KWAN
MEDIUM: WATERCOLOUR

The underpainting was done with burnt umber and I dripped turpentine on top to create the corrosive effect. For the blurred edges, I used light repetitive brushstrokes from left to right with a clean, dry brush.

THE CYCLE
BY SHARMAINE KWAN
MEDIUM: WATERCOLOUR

I first painted the blue coloured areas, followed by the red and then the yellow. Some of the brushstrokes were applied in a single stroke to leave its mark, whereas other patches in the background were blended.

ROSES BY MATTHEW EVANS
MEDIUM: ACRYLIC

Step 1

Working on a small piece of smooth surface mounting card – a great ground for acrylic – I drew an outline of some roses with a coloured pencil. I enjoy the pattern qualities of rose petals and their sweeping lines which can be emphasized to enhance movement within the composition. Fibre-tipped pens were used to strengthen some of the central lines so they will still be able to be seen through the acrylic paint at the next stage.

Step 2

I now used acrylic paint to block in the colour of the floral design. The ivory ground enhances the vibrancy of the colours, and the green of the leaves creates a contrast. The brushstrokes mirror the circular movement of the rose petals. The fibre-tipped pen lines can still be seen here through the semi-opaque acrylic paint, which is effective either used in a similar way to watercolour or as an impasto medium.

Final Painting

I gradually built up more layers of acrylic, darkening and strengthening the background so the roses shine out. A lighter coloured acrylic was used to give detail to the petals and enhance the swirling composition. Soft pastel was also added at the end for extra highlights; this is a useful technique to use on top of dry acrylic.

FANTASY FISH
BY KARIN ZELLER
MEDIUM: ACRYLIC ON CANVAS

Step 1

I don't always do this, but for this painting, I drew a simple design with Faber Castel water-soluble Inktense sticks directly on to the canvas. Accuracy doesn't matter because mistakes can be corrected later.

Step 2

The next step was to use a watery wash. I used Art Spectrum inks and acrylics, in a cool palette of blues and greens, to block in some colours and create textures. I used a variety of techniques to apply the paint, including fingers, stamping, spray bottles to create drips and bubble wrap painted with acrylics and then stamped on to the canvas. I wanted to create some textures and movement.

Step 3

I continued to build up the colour. As I also wanted to build up thicker textures, I added some gels and texture mediums as well as applying heavier paints, such as Matisse Structure, which can be applied with a palette knife.

Final Painting

I originally planned to paint this in only greens and blues, but I felt it needed some contrasting bright colours, so I added warm accents of yellows, oranges and reds.

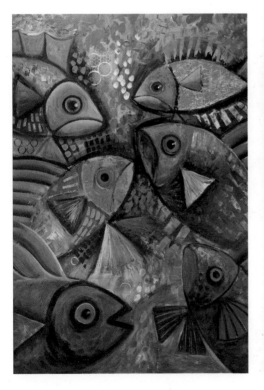

FANTASY FISH NO. 2 BY KARIN ZELLER
MEDIUM: ACRYLIC ON CANVAS

Final Painting

I used similar techniques in this painting as with the painting on the previous page. To achieve this result, I used many layers of paint and lots of tools to apply it with. These included bubble wrap, plastic lids, square-shaped brushes, palette knives and fingers. I also scraped back some paint using plastic cards and palette knives. For the final layers, I also applied the details, such as the highlights in the eyes.

Quick Tip: I usually brush on Atelier Fast Medium Fixer, which makes the painting shiny and bright, before adding a final gloss varnish. Varnish can be sprayed on or brushed on.

BIRDY BY LUKÁŠ KUBLA

PAINTING APPLICATION: PHOTOSHOP

Step 1

I began by making a sketch. It's just a simple sketch, something that I do at the beginning of every creative process.

Step 2

Here, I roughly mapped out my composition and added some basic colours.

step 3

I added more colours to improve the picture. I often use brushes and the Smudge Tool in Photoshop for a better result. This gives me a similar effect to oil paints blurring on a canvas.

step 4

My main purpose in this step was to create an atmosphere within the painting. I used my favourite Photoshop effects: nebulae and space-art (it is free to download nebula effects). I often combine different nebulae for a striking result.

Step 5

This painting is almost finished and just needs a few finishing touches to give it a great atmosphere. I used the Brush Tool to create lines, both straight and free-flowing.

Final Painting

In the final step, I only needed to make small adjustments to the painting: I used some overlays and Clipping Masks, carried out contrast editing using the Gradient Map tool and, at the very end, I used the Unsharp Mask filter.

BRUGES NO. 6 BY ROSEY HANCOCK
MEDIA: GLOSS AND ACRYLIC

Step 1

Once I have come up with an idea, I make my canvas to the size required and draw it out with an HB-3B pencil using a grid or projector, if it is a large piece.

Step 2

When I was happy with the initial sketch I proceeded to draw over the pencil using a small nibbed craft bottle containing black gloss paint. The nib must be fine to stop the paint spreading when it is applied.

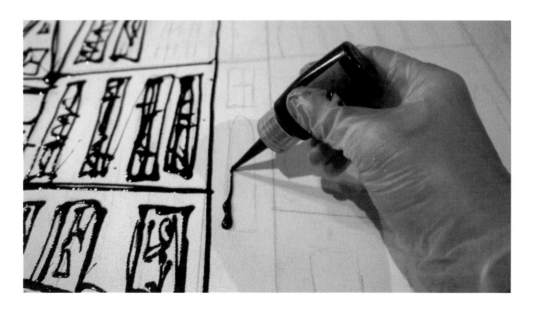

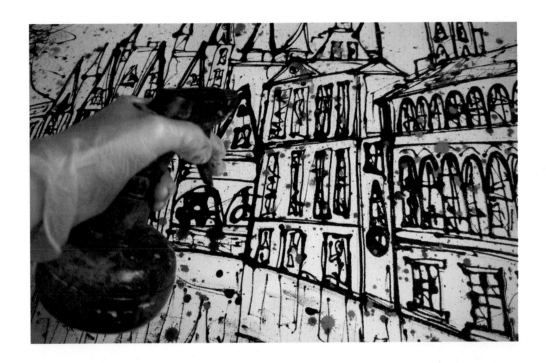

step 3

After a good 36 hours drying time, the painting
was ready for the acrylic ink layering.
I chose three inks in a similar colour scheme
(browns/oranges/yellows) and using the pipette
I dropped ink all over the painting. Using a
water sprayer, I spread the inks to achieve the
desired effect. I let this dry and then repeated
the process using a complementary colour
scheme. I didn't go too dark with the painting
at this stage and left areas of white.

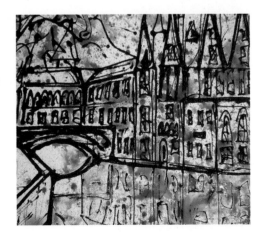

step 4

Once I was happy with the dry ink layers, I dripped glossy enamel paint randomly all over the painting using complementary/contrasting colours. This will really stand out against the wishy washy inked background.

step 5

When all the layers were dry, I touched up the black
gloss lines. These may have become dull and even
slightly covered with layers of inks and enamels. Using
a paint brush, I went over the lines to make the image
stand out against the colourful background.

step 6

The next step was to add highlights of colour over
the inked background using a paintbrush and acrylic
paint. Use light and/or dark paint to add perspective
and depth; the use of a contrasting colour works
well too.

Step 7

Once the painting was completed, the final stage was to finish using a clear art resin. This is an epoxy two-part mix made especially for artwork, giving it a glass like finish and protecting it. The inks dry quite dull, but finishing with the resin makes the colours pop on the canvas.

I mixed the two equal parts together, stirred for three minutes, then using a heat gun, pushed out as many air bubbles as possible before applying it with a foam brush. Using the brush, I smoothed

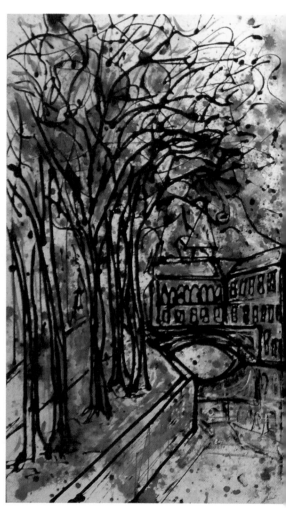

the resin as evenly as possible over the painting. As the resin was drying, I ran a foam brush along the edge of the canvas to smooth out any drips that had formed. The resin dries really hard so

better to resolve this immediately, although it can be sanded down after drying.

Final Painting

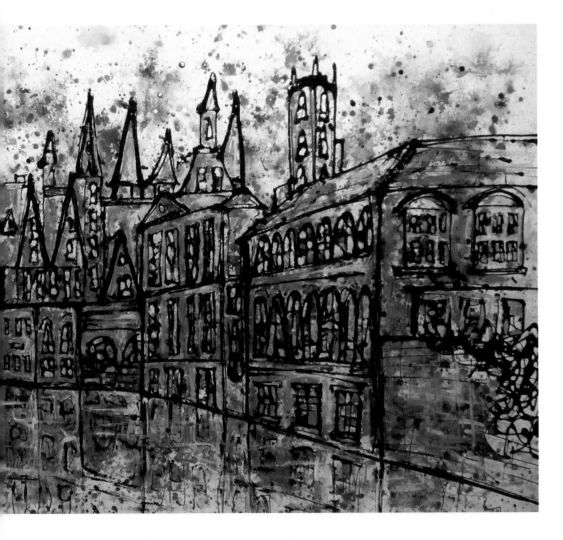

BLUE BROKEN FACE BY DEBORAH WAINWRIGHT
MIXED MEDIA

Step 1

You can die-cut shapes and stick them on the substrate. Here, I used frame shapes stuck in a large journal. Using a stencil and craft paste, I filled in some of the flatter areas.

Step 2

Once the paste was dry, I used white acrylic over the top to give the piece some cohesion. I dried this off with a heat gun and then spritzed the page with water. Next, I sprinkled on pigment crystal. As soon as they touched the water, they burst into colour.

Step 3

Using watercolour paint, I roughly painted a face. Once dry, I cut it out, then cut it up. I placed the cut-up pieces around the page to find the best composition. Then I stuck the face in place.

Final Painting

Before the piece was finalized, I added sentiment, as seen in the centre here.

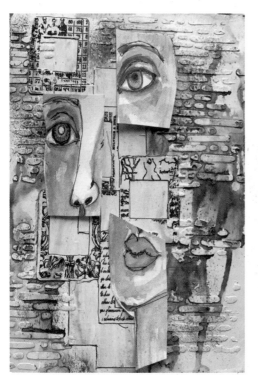

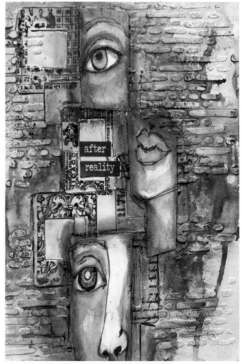

VENUS IN BIRD BY KUN FANG

MIXED MEDIA

In this painting, I used Amsterdam Acrylic paint, which has a rainbow variety of colours, and a variety of brushes.

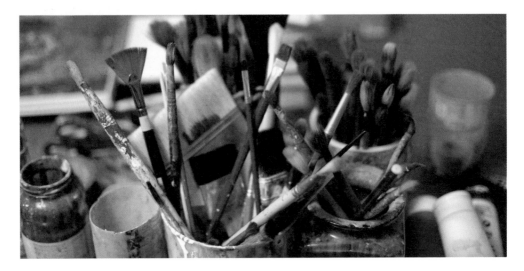

 step 1

First, I drew a sketch on to the rice-paper canvas with brown paint powder.

step 2

Next, I added blue paint with my fingers.

step 3

I added yellow details to give the painting highlights.

step 4

Here, I added another detail in red paint and completed it with white acrylic.

step 5

I added some more small details to my canvas using a variety of colours.

step 6

I am nearly there, and
add the finishing touches
to my painting.

Final Painting

My work, *Venus In Bird*, is finished. It is my response to the effects of twenty-first-century urban living: beauty and freedom are two wings that fly high when everyone else is going low. Venus is the beauty and bird is the freedom.

RAINBOW CATS BY KARIN ZELLER
MEDIUM: ACRYLIC ON CANVAS

Step 1

First, I made a small sketch or doodle, done with a black ballpoint pen in a sketch book. Sometimes I also add colour, or do a doodle with a Koh-I-Noor coloured magic pencil (which has three colours in one pencil). The sketch is a starting point only, and I don't stick with it religiously. I allow inspiration to take over while I paint. I find that the most exciting thing about painting is not knowing how it will turn out.

I often use doodles and sketches (similar to this one) to get the creative juices going, or to plan a painting.

Step 2

I often start with some kind of background. In this case, I decided on a rainbow-coloured one, painted on very quickly with large brushes and acrylic paint. For the first layers I often use less expensive, good-quality student acrylic paints, rather than the expensive artist-quality paints, which I reserve for the final layers.

step 3

For this stage, I used white chalk (ordinary chalk, that you use for chalk boards) for the outlines of the cats. This is easy to remove or paint over, so I feel quite free and fearless as I do a very quick drawing directly on to the canvas.

step 4

If I'm happy with the chalk drawing, I use black paint to paint in the outline, and also use a damp rag to blend some of the shadows to create the beginnings of some depth and form.

Step 5

There are many layers of paint between Steps 4 and 5. In early layers, I sprayed the canvas, to encourage random marks and drips. I used fingers, brushes, lids and plastic cards to apply paint and create marks and patterns. While I loved many of the cats at this stage, as a whole the painting lacked unity and harmony. I had to continue working on it until I felt it was balanced and harmonious.

Final Painting

I was finally happy with it, although I could have continued working on it some more. I like the fact that you can still see the rough beginnings. I did not want to give up some of the random drips. I love the little owl, which distinguishes the painting from my many other rainbow cat works, and adds a bit of humour.

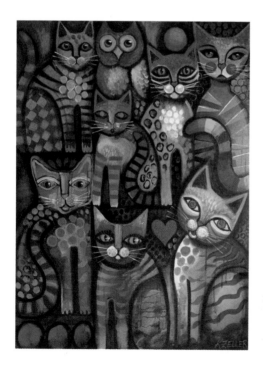

MEMORY FILM BY SHARMAINE KWAN

MEDIUM: OIL

This oil painting is inspired by surrealist ideas and the unconscious mind. I painted the darker tones first and applied thick white paint to areas such as the clouds last.

THE CALL BY SHARMAINE KWAN

MEDIUM: OIL

The repetition of colour along with the consistent style and brushstrokes I used creates a sense of unity in this painting. There is also a play between warm and cool colours which adds to the pulsing effect.

MEET THE TEAM

Get to know the artists who made this book, and find out where you can see more of their work. They come from all over the world, from a wide range of backgrounds, some self-taught and some with formal art education. Some create their art digitally, others use traditional techniques; some mix their media to achieve their desired result. Their energy and enthusiasm for making art is the common thread that unites them all.

DAVID COUSENS
(DIGITAL ART INTRODUCTORY TEXT)

Award-winning illustrator David Cousens blends a mixture of Eastern and Western influences to create a stylized world of illustration that's dynamic, cinematic, sometimes insane (in the best way), often cheeky and positively filled with colour. David has written books teaching digital art and provided illustrations for advertising, branding, concept art, editorial, exhibitions, education, publishing, video games and television.

Website
www.CoolSurface.com

SHARMAINE KWAN
(CHAPTER INTRODUCTIONS AND TRADITIONAL ART INTRODUCTORY TEXT)

Sharmaine Kwan is an artist from Hong Kong. She works in a range of areas which includes painting, illustration, contemporary art, video and design.

She has received many awards from international art competitions and her work has been shown in over 30 exhibitions worldwide in cities such as London, Moscow, Athens and Beijing.

Website
www.sharmainekwan.wixsite.com/kwan

AARON MILLER
(TECHNICAL EDITOR)

Aaron is a freelance illustrator and designer from Cheltenham, England, with over 10 years' industry experience, working with household names and huge multinational companies from all around the world. From illustration and art direction through to designing for digital media and print, Aaron's imaginative concepts and understanding of colour theory combine to create a striking, unique style.

Website
www.aaronmillerillustration.com

TOM HOVEY
(FOREWORD)

Tom Hovey is a Welsh illustrator based in Bristol. Tom's multidisciplinary approach has seen him apply his unique style across a broad spectrum of genres including TV graphics, food illustration, editorial, book illustration, storyboarding, animation, apparel design and murals. Tom is best known for his acclaimed food illustration work. He has produced the illustrated graphics for BBC One's *The Great British Bake Off* since its inception in 2010, and his signature style has been a key element in the show's success.

Website
www.tomhovey.co.uk

AMANDA BATES

Amanda lives with her young family in a village nestled at the foot of the North Downs in Hampshire, England. She studied science and enjoyed a career as a technical writer, and is now concentrating on her lifetime passion: art. She takes inspiration from the world around her, and sees each work as a moment captured in time.

Website
www.amandabatesart.co.uk

SUZANNE CLEARY

Suzanne Cleary studied fine art in her home city of Dublin. She specializes in modern still life and prefers working with acrylics for their versatility. She is keen to progress in the art industry and embark on new challenges, experimenting using different materials and concepts. Suzanne is currently working on paintings for restaurants in the Andalucia region of southern Spain.

Website
www.facebook.com/suzannec-learyartist

OLGA DABROWSKA

Olga is a painter and writer based in Poland. She has a great passion for nature, which is reflected in her art.

Website
www.orselis.deviantart.com

MATTHEW EVANS

Matthew has a lifelong love of art and photography; his many favourite themes include florals, sunsets, seascapes and townscapes. His art has provided him with a wonderful hobby and he has been able to exhibit locally, nationally and on the internet.

Website
www.facebook.com/matthewevansartist

KUN FANG

Kun was born in Shanghai and grew up in Beijing before moving to Belgium to study at the Antwerp Academy. She now lives and works in Antwerp. Kun has taken part in many exhibitions, both solo and

collective. Her artistic style is a blend of East meets West, black and white, figurative and abstract, and her main inspirations are Picasso, Qi Baishi, Matisse, Kahlo and Chagall.

Website

www.kunfang.be

ALEXANDRA FINKELCHTEIN

Alexandra was born in Moldova and travelled the world to take her degrees: Bachelor of Fine Arts at Concordia University, Canada, and Master of Fine Arts at New York Academy of Art. Around that time, Alexandra developed her distinctive techniques and started to exhibit worldwide; her works are included in many public and private collections, as well as featured in the book *The Figure: Painting, Drawing, and Sculpture* (Margaret McCain (ed.), Skira Rizzoli, 2014).

Website

alexandraegorovfinkelchtein.wordpress.com

JOSEPH FRANCIS

After graduating from Duke University, in Durham NC, USA, with degrees in Computer Science and Studio Art, Joseph Francis began his career in computer animation in New York City, focusing initially on broadcast television commercials, before moving west to contribute to the Hollywood feature film and video game industries. He currently lives in Los Angeles with his wife and daughter.

Website

https://www.artstation.com/artist/
digitalartform

ROSEY HANCOCK

Rosey graduated from Norwich School of Art in 2006. She continued to paint part-time in between jobs before returning to her Suffolk roots in 2007. Soon afterwards, she became a picture framer at RAF Lakenheath's Arts and Crafts Centre, and has continued to work there for nearly 10 years. Rosey also paints part-time, teaches art classes, displays her work regularly and sells her artwork locally.

Website

www.paintingpassions.co.uk

SIRIS HILL

Siris is a self-taught painter, whose work is centred around the darkest profundities of the human mind. His work visually describes the feelings and emotions felt from living with a mental illness. He hopes to fill the gap between those suffering and the general public by raising awareness of the reality of living day to day with these invisible disabilities, in an attempt to create a more empathetic society and alleviate the stigma surrounding mental illness.

Website

www.sirishill.co.uk

DANI HUMBERSTONE

Award-winning artist Dani Humberstone is a trained fashion designer, book illustrator, graphic designer, greetings card artist, gallery manager and curator. She currently owns and runs an art shop and creative hub in East Sussex. Dani has exhibited her work at numerous art fairs and galleries, and has written several books on painting for Search Press Ltd. She is the vice president of The Society of Women Artists.

Website
www.danihumberstoneart.com

MICHELLE KONDRICH

Michelle Kondrich is a commercial artist specializing in editorial illustration. She was born and raised in rural Nebraska where she excelled at things like musical theatre, the trumpet and painting her high school's mascot (a bulldog) in tempera paint on local business windows during Homecoming. She lives and works in Providence, Rhode Island, USA, with her husband and daughter.

Website
www.michellekondrich.com

LUKÁS KUBLA

Lukás Kubla has been interested in art for about 10 years, and digital art specifically for the past four. As well as working to improve his digital painting skills, he would also like to develop his skills in painting on canvas, particularly abstract portraits.

One of his greatest sources of inspiration is online artist Agnes-Cecile: he calls her style 'breathtaking'. He is currently studying engineering at university.

Website
kybeel.artstation.com

EVVIE KYROZI

Evvie Kyrozi is a visual artist from Greece. She studied animation and works using mainly oil and acrylic on canvas, but also digitally, creating illustrations and comics. She started painting at a young age, is a member of various artistic societies and has also taken part in many group exhibitions in Greece and abroad.

Website
www.everlastingart.gr

JULIE NASH

Julie Nash is a qualified art tutor and author based in Lancashire, England. She holds demonstrations and weekly workshops, helping others to enjoy art, and has recently begun producing tuition videos. Her many years of experience, combined with professional teaching qualifications, enable her to pass on her expertise and knowledge to others in a friendly, relaxed and highly effective manner. She exhibits her art regularly, and her portfolio includes portraiture, pets and equestrian, wildlife, still life and landscape subjects.

Website
www.julienash.co.uk

GIOTA PARASKEVA

Panagiota Paraskeva studied graphic design and works as a visual artist. She has been expressing herself through drawing and painting since her childhood. Nowadays, her paintings are mostly abstract, each one of them a journey towards deeper feelings and emotions. She mainly uses acrylics but also enjoys working with oils, watercolour, charcoal and ink.

Website
www.bugsdesign.gr

BARBARA PICKERING

Barbara lives in Barbados and has been drawing and painting all her life. She paints mainly in oils and her work varies from expressive faces and mood-inspired seascapes and landscapes to issues of humanity. As she tries to depict the essence of human nature, she hopes her art sparks emotion for the viewer.

Website
www.bapickeringart.com

ERIKA RICHERT

Erika Richert is a portrait and gallery artist with a distinctive expressionistic style. Erika works hard to impart to the viewer the same impression of character, temperament and mood that she gets from her observation of the individual and then to 'punch it up'. One of her subjects actually said of her portrait, 'That looks more like me than I do!'

Her work has been shown in a number of galleries in the San Francisco Bay Area, California, and she has painted many privately commissioned portraits, which include pets.

Website
www.erikarichert.wixsite.com/artist

STEPHEN ROSE

Stephen Rose (R.A. Dip) has exhibited extensively in Europe and the UK and his paintings are in collections around the world. He is an experienced painting tutor and the author of a book on painting, commissioned by Winsor and Newton. Stephen has also contributed images to various other publications. Stephen is a member of the Art Workers' Guild and lives in the UK.

Website
www.stephenrose.co.uk

SEBASTIAN

Sebastian is a self-taught Italian artist living in Austria. Although he has not received any formal training in art, painting is an important part of his life. He paints mainly landscapes in oil and gouache.

Website
www.paintingsbysebastian.com

KARLA SMITH

Karla Smith says: 'My passion for painting has been my personal goal. Art is a never-ending process of learning and pushing forward. I enjoy thinking of ideas and then seeing how they form into a painting. One of the things I love so much about art is the continued learning process; there isn't an end point – just keep moving forward! I am also able to show my dedication and respect for nature through my art.'

Website

www.karlasmith.artspan.com

SANDRA TRUBIN

Sandra Trubin says: 'Visual art in all of its forms has always been a passion of mine, from painting and drawing to sculpting and even various crafts and designs. I find inspiration for my work in many different places: the magnificent nature that surrounds us, an imaginative idea or even something as silly as a colour combination can ignite the creative spark.'

Website

www.sandratrubin.weebly.com

DEBORAH WAINWRIGHT

Deborah has always loved to draw faces; she began painting them four years ago after being inspired by various artists whose online classes she took. She often incorporates her faces on to mixed-media backgrounds which she creates by building up layers of texture and colour.

Website

http://dawainwright.blogspot.co.uk

KARIN ZELLER

Born in Germany and Canadian by nationality, professional artist Karin Zeller now lives in Melbourne. Mostly self-taught, she credits the art classes, artists, teachers, art courses, workshops, books and online tutorials which have inspired her and helped her develop her skills in drawing, watercolour and acrylics. As well as exhibiting her art, she teaches others and uses her artwork in designs for clothing, bags and more that she sells online.

Website

https://www.redbubble.com/
people/karincharlotte?asc=u

DEMI ZWERVER

Demi is a mostly self-taught artist from the Netherlands. She's been drawing all her life, and started drawing digitally in 2013. She became interested in digital painting in 2016 and decided to leave manga behind. She is currently studying game art with a view to becoming a concept artist, character designer or illustrator.

Website

bluemadness.artstation.com

USEFUL INFORMATION & FURTHER READING

INFLUENTIAL ARTISTS

Take a look at the work of some of these artists to give you further inspiration in your chosen genre.

STILL LIFE

Giovanni Ambrogio Figino
 (1540–1608)

Joris Hoefnagel (1542–1601)

Juan Sánchez Cotán (1560–1627)

Georg Flegel (1566–1638)

Fede Galizia (1578–1630)

Peter Binoit (1590–1632)

Adriaen van Utrecht (1599–1652)

Willem Kalf (1619–93)

Carl Hofverberg (1695–1765)

PORTRAITS & FIGURES

Leonardo da Vinci (1452–1519)

Michelangelo (1475–1564)

Peter Paul Rubens (1577–1640)

Johannes Vermeer (1632–75)

Édouard Manet (1832–83)

Edgar Degas (1834–1917)

Pierre-Auguste Renoir (1841–1919)

Paul Gauguin (1848–1903)

Egon Schiele (1890–1918)

Lucian Freud (1922–2011)

Keith Haring (1958–1990)

THE GREAT OUTDOORS

Caspar David Friedrich (1774–1840)

J.M.W. Turner (1775–1851)

John Constable (1776–1837)

Claude Monet (1840–1926)

Vincent van Gogh (1853–1890)

Edward Hopper (1882–1967)

Richard Diebenkorn (1922–1993)

Richard Estes (b. 1932)

Yvonne Jacquette (b. 1934)

David Hockney (b. 1937)

Anselm Kiefer (b. 1945)

Thomas Kinkade (1958–2012)

Peter Doig (b. 1959)

Amy Park (b. 1972)

ABSTRACT

Paul Cezanne (1839–1906)

Wassily Kandinsky (1866–1944)

Piet Mondrian (1872–1944)

Paul Klee (1879–1940)

Pablo Picasso (1881–1973)

Jean Metzinger (1883–1956)

Mark Rothko (1903–1970)

Salvador Dali (1904–1989)

Jackson Pollock (1912–1956)

Wu Guanzhong (1919–2010)

Cy Twombly (1928–2011)

Frank Stella (b. 1936)

Gerhard Richter (b. 1932)

Sigmar Polke (1941–2010)

Sue Williams (b. 1956)

Jean-Michel Basquiat (1960–1988)

Chris Ofili (b. 1968)

Cecily Brown (b. 1969)

DIGITAL ARTISTS

Charles Csuri (b. 1922)

Pascal Dombis (b. 1965)

Casey Reas (b. 1972)

Cory Arcangel (b. 1978)

Rafaël Rozendaal (b. 1980)

Jon Rafman (b. 1981)

Nicolas Sassoon (b. 1981)

Alexandra Gorczynski (b. 1983)

Petra Cortright (b. 1986)

Molly Soda (b. 1989)

TOP FIVE DIGITAL PAINTING APPS

Download one of these painting apps and get creative on the move.

ArtBoard Creative Drawing: This app offers a canvas, plenty of configurable and responsive brushes and multiple layers with blending modes. Android. Free.

ArtRage: A traditional painting app that's easy to use while retaining lots of customization options. Very easy learning curve with professional-level standards. Android and iOS. £4.99/$4.99.

Infinite Painter: This app has a wealth of features, including symmetry and perspective guides. Android and iOS (iPad). Free 7-day trial.

Pixelmator: A high-end app that offers a high level of finish and control. iOS. £4.99/ $4.99.

Zen Brush: This app emulates the feel of Japanese calligraphy brushes. Android (free) and iOS (£2.99).

USEFUL WEBSITES

artshow.com/resources/painting.html
A substantial list of tutorials on art, painting, watercolour, oil and acrylic style, and finding the right art supplies.

www.artstation.com
A showcase site for artists based in various fields of entertainment, including video games and film.

www.deviantart.com
One of the most popular online art websites, showcasing tens of millions of artists across all fields and styles.

www.paintergallery.com
A database with links on dozens of art subjects, including an A-Z of links to individual artists.

www.painters-online.co.uk
News articles and blogs on art, artists and art events, plus an online art gallery and market.

painting.about.com/od/paintingforbeginners/u/painting_path5.htm
Step-by-step demos on abstract, landscape, wildlife, seascape paintings and more.

www.wetcanvas.com
A series of online 'channels' delivering such content as lessons, discussions and reviews, as well as a platform for online artists.

FURTHER READING

Akib, Hashim, *Painting Urban and Cityscapes*, The Crowood Press, 2017

Hornung, David and James, Michael, *Colour: A Workshop for Artists and Designers*, Laurence King, 2012

Mateu-Mestre, Marcos, *Framed Ink: Drawing and Composition for Visual Storytellers*, Design Studio Press, 2010

Petry, Michael, *Nature Morte: Contemporary artists reinvigorate the Still-Life tradition*, Thames and Hudson Ltd., 2013

Schonlau, Julia, *1000 Portrait Illustrations: Contemporary Illustration from Pencil to Digital*, Quarry Books, 2012

Todhunter, Tracey, *Artist's Painting Techniques*, Dorling Kindersley, 2016

Van Vliet, Rolina, *Painting Abstracts: Ideas, Projects and Techniques*, Search Press, 2008

Various, *Master the Art of Speed Painting: Digital Painting Techniques*, 3dtotal Publishing, 2016

Wilson, Kate, *Drawing and Painting: Materials and Techniques for Contemporary Artists*, Thames and Hudson Ltd., 2015

Wolf, Norbert, *Landscape Painting*, Taschen, 2008

Zeller, Robert, *Figurative Artist's Handbook: A Contemporary Guide to Figure Drawing, Painting, and Composition*, Monacelli Press, 2017

INDEX

Artists' Websites

David Cousens: www.CoolSurface.com
Sharmaine Kwan: www.sharmainekwan.wixsite.com/kwan
Aaron Miller: www.aaronmillerillustration.com
Tom Hovey: www.tomhovey.co.uk
Amanda Bates: www.amandabatesart.co.uk
Suzanne Cleary: www.facebook.com/suzanneclearyartist/
Olga Dabrowska: www.orselis.deviantart.com
Matthew Evans: www.facebook.com/matthewevansartist
Kun Fang: www.kunfang.be
Alexandra Finkelchtein: alexandraegorovfinkelchtein.wordpress.com
Joseph Francis: https://www.artstation.com/artist/digitalartform
Rosey Hancock: www.paintingpassions.co.uk
Siris Hill: www.sirishill.co.uk
Dani Humberstone: www.danihumberstoneart.com
Michelle Kondrich: www.michellekondrich.com
Lukás Kubla: kybeel.artstation.com
Evvie Kyrozi: www.everlastingart.gr
Julie Nash: www.julienash.co.uk
Giota Paraskeva: www.bugsdesign.gr
Barbara Pickering: www.bapickeringart.com
Erika Richert: www.erikarichert.wixsite.com/artist
Stephen Rose: www.stephenrose.co.uk
Sebastian: www.paintingsbysebastian.com
Karla Smith: www.karlasmith.artspan.com
Sandra Trubin: www.sandratrubin.weebly.com
Deborah Wainwright: http://dawainwright.blogspot.co.uk
Karin Zeller: https://www.redbubble.com/people/karincharlotte?asc=u
Demi Zwerver: bluemadness.artstation.com

FLAME TREE PUBLISHING

Creators of fine, illustrated books, ebooks & art calendars

www.flametreepublishing.com
blog.flametreepublishing.com